# COLLINS · Learn to draw

# Wildlife

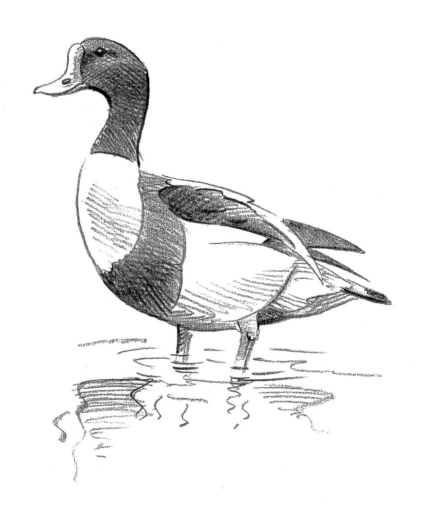

# PETER PARTINGTON

First published in 1995
by HarperCollins*Publishers*, London

99 01 02 00
5 7 9 10 8 6 4

© HarperCollins*Publishers* 1995

*Editor: Diana Craig*
*Art Director: Pedro Prá-Lopez, Kingfisher Design Services*
*DTP/Typesetting: Frances Prá-Lopez, Kingfisher Design Services*
*Contributing artists: John Busby, John Davis, Martin Hayward-Harris*

A catalogue record for this book is available from the British Library

ISBN 0 00 413362 5

Printed in Hong Kong by Sing Cheong Printing Co. Ltd.

# CONTENTS

# Introduction

Animals and birds are an endless source of interest to us – after all, we ourselves are animals and we share the Earth with them. Theirs is a world that is alive, beautiful and of endless variety. We admire their grace, their character, their innocence, their complexity, and this makes us want to study and record these things.

**Perennial fascination**
Animals have been the subject of art since the first prehistoric artists scratched pictures on stone, or finger-painted on cave walls.

Today, there is a new fascination with them, not just as creatures to be hunted, domesticated, classified – or even eradicated – but simply as wonderful, free, living beings in their own right. We also know much more about animals and their world, and understand more about the way in which they interact with each other and with their landscape.

Artists have always found this kind of holistic approach more friendly, and there is a growing and enthusiastic audience for the depiction of animal personality and life.

Nowadays, there are also greater opportunities to watch animals living their lives, whether it's from hides in reserves or simply near the bird-feeding table in the garden.

The great improvement in binoculars, telescopes and cameras allows us to get closer to animals and birds – almost to enter into their most intimate lives – without disturbing them unduly.

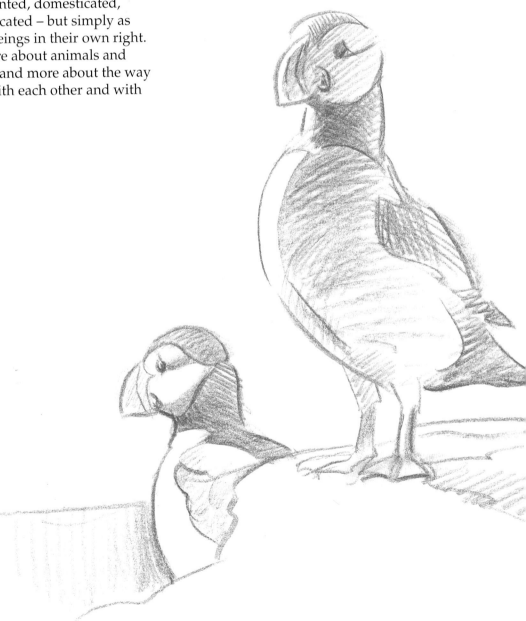

Working from cars and hides is a help – use any means which enables you to be invisible to the animal you are watching.

Observe the Countryside Code, take home your litter, and shut gates after you. There are often wardens and rangers present on nature reserves; take their advice when visiting. They will help you and will know what animals are likely to be in the vicinity.

**The Countryside Code**
If you want to observe animals at their most natural, the best approach is to disturb them as little as possible. Try to remain quiet and tread carefully. If possible, avoid standing on high ground where you would be more visible, and do not approach a bird on a nest or an animal with young. Try to remain aware of what is around you. It is amazing what you can see if you remain still.

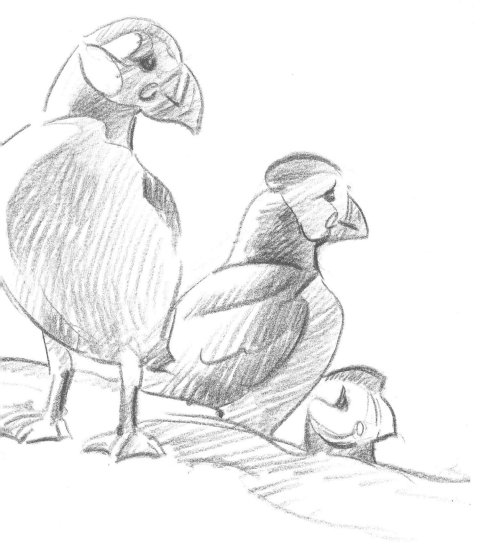

# Tools and Equipment

When you begin drawing, you will find an exciting array of materials to choose from. They have been developed by artists to suit their own purposes. Each tool creates its own feeling and effect. They can all be used in wildlife drawing to capture the movement and diversity that animal life presents to us.

## Pencils

The pencil, that everyday object, is one of the most versatile drawing instruments available to us, capable of producing rough, quick sketches and finely worked detail. The graphite or 'lead' pencil ranges from the super-hard 9H to the luxurious and softest 9B, with the HB in the middle. The H range provides you with a light, hard, precise line ideal for careful studies of eyes, fur and feather. The soft B range can provide rich, rough, textural effects and striking tonal variations. The trail of graphite on the paper can be smudged to create depths and lights, and a sense of action and movement.

Some people prefer specialized pencils, such as the clutch and propelling pencils. These come in a lower range of hardness and softness, but offer a continuous and consistent line without the bother of constantly having to sharpen the lead.

Coloured pencils enable you to draw and introduce colour simultaneously, while watercolour pencils produce a line which can be softened with a wash of water.

You should experiment with as many different types of pencil as possible to discover what effects they produce and which suits your intentions and feelings best.

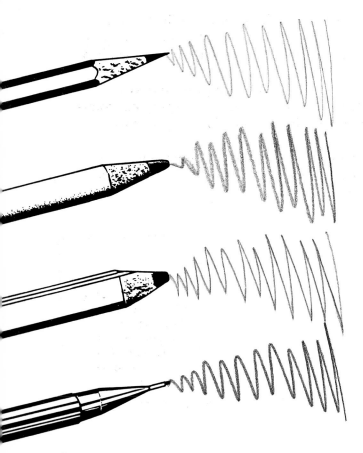

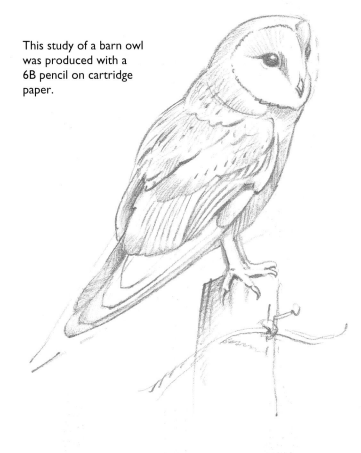

This study of a barn owl was produced with a 6B pencil on cartridge paper.

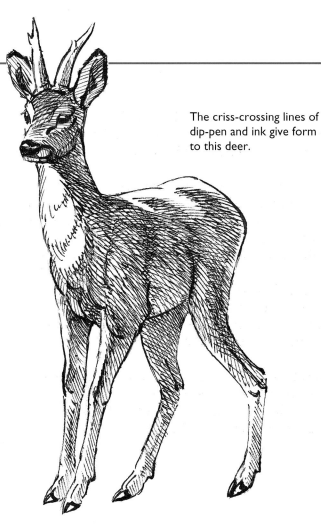

The criss-crossing lines of dip-pen and ink give form to this deer.

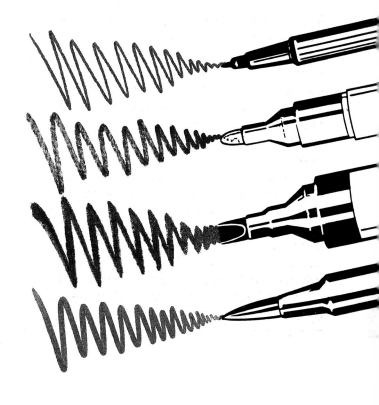

## Pens

Pens can produce a fluid, uncompromising line. They are available in several varieties, each creating a different effect.

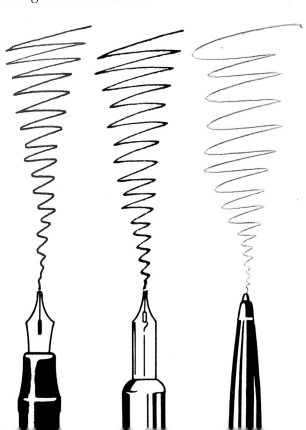

**Fountain** and **dip-pens** allow the artist to draw free-flowing or angular lines of varying thickness, depending on the pressure applied.

**Ballpoint** and **technical pens** produce a consistent, fine line. Quick to apply, ballpoints are useful for sketching moving animals.

**Felt-tip pens** can create a similar effect, depending on their nibs. They are sold in a range of widths.

### Artist's Tip

*Dip-pens need washing after use, especially if you have used waterproof ink. This can encrust itself on the nib if it dries and will clog the pen.*

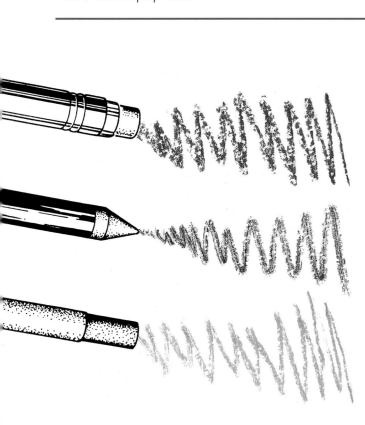

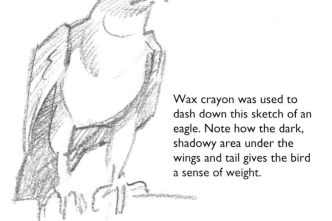

Wax crayon was used to dash down this sketch of an eagle. Note how the dark, shadowy area under the wings and tail gives the bird a sense of weight.

**Oil pastels** and **wax crayons** come in a dazzling array of colours, both bright and subtle. They give us the opportunity to introduce colour at the same time as line and contour. Soft oil pastels can be built up to resemble oil paint. Wax crayon drawings can sometimes become overworked – use overlapping, *cross-hatched* (criss-crossing) lines with care.

These 'greasy' media are all difficult to erase, so plan your picture carefully before you begin.

### Pastels, crayons and chalks

The varied textures and tones that pastels and chalks produce offer an exciting alternative to the precision of pencils and pens. They work best on rough and textured papers.

The range of rich, powdery marks and lines produced by these materials can be smudged and blended. They are ideal for rendering the depths of deep fur or the sheen on a glossy coat because you can work light over dark, or allow the coloured paper base to show through.

**Pastels** and **chalks** can be used on their tips or on their sides to fill large areas quickly. Their rough unfocused line can suggest light, movement and mood – the eye fills in much of the detail the artist has merely suggested. They are particularly effective if you want to produce lively, spontaneous drawings.

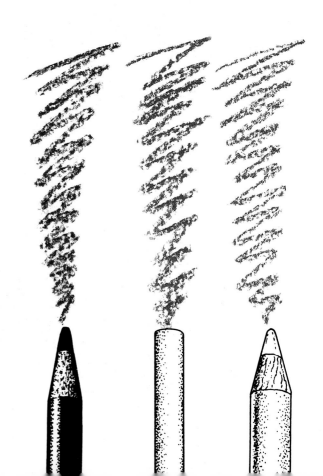

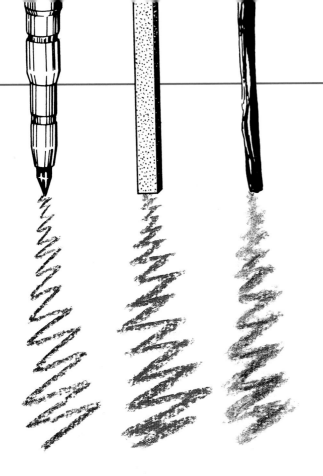

**Compressed charcoal** and **conté pastel** are also made in pencil form for ease of handling. Their effect is similar to non-compressed forms, but more manageable for smaller scale work.

**Compressed graphite sticks** resemble large-scale pencil 'leads' in various softnesses, and produce effects like generous pencil strokes. They can apply graphite to paper in quantity and with speed.

The boldness and speed with which you can apply graphite stick makes it an ideal medium for capturing a fleeting subject, such as these badgers.

### Artist's Tip

While working with these delicate media, rest your hand on a piece of paper to protect completed areas from smudging, and cover them when you take a break.

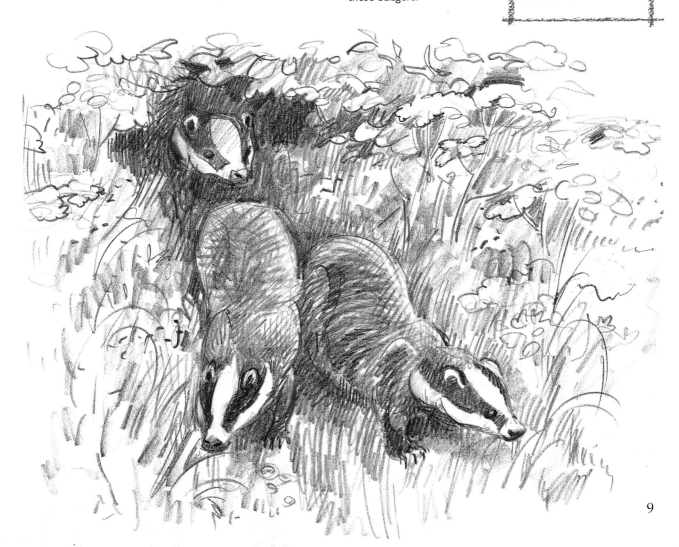

9

## Brushes and wet media

Brushes can be used to add colour or tone to a drawing or as a drawing implement in their own right. They can produce fine, flowing, thick or thin, rhythmic lines.

Brush tips come in various shapes. The most useful for drawing are the long-tipped, pointed brushes – the 'rigger' type being the longest. These produce long, fine lines. Short-tipped points are easier to control and can be used for fine detail.

Flat brushes, either short or long, are the best type for covering large areas, or for producing extreme variations of line, almost like a calligraphic pen.

**3** For an even layer of strong watercolour, add darker washes to a light wash while still wet.

**4** To prevent colours 'bleeding' together, let the first layer dry before adding the next.

**5** For a soft, blurry effect, paint watercolour on to paper that has been slightly dampened.

**6** Ink or concentrated watercolour on damp paper will spread into swirls and blotches.

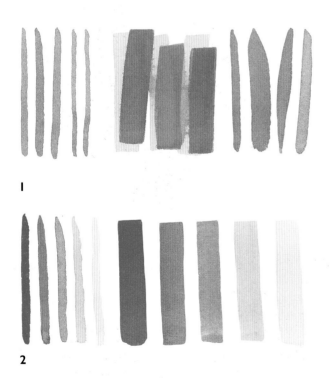

**I** These brush marks were made with *(from left to right)* a small, pointed brush; a flat brush; and a large, pointed brush.

**2** Watercolour tone can be progressively reduced by adding more water, as shown by these strokes using different dilutions.

Sable is the best-quality hair in a watercolour brush and gives very attractive results. Cheaper squirrel and synthetic fibres are quite adequate, however, and produce work of good quality. The tensile springiness of synthetic fibres can create fine, dynamic lines ideal for expressing the liveliness of animals.

Brush-pens, with a cartridge of coloured ink, are good for this, too, and ensure a consistent flow of colour.

It is possible to draw in any medium, including oil paints, but it takes a lot of practice to get the best out of these. Water-based paints or inks are easier and more convenient to handle, and they dry more quickly.

**Watercolour** can be diluted with water to give transparent tones and gentle washes. Reducing the amount of water produces strong vivid colours – a very effective technique when used to strengthen pencil outlines or an ink drawing.

**Gouache** is a form of watercolour that gives bold, opaque colour and can mask pencil sketching.

**Acrylic** paints can be diluted to create a watercolour effect – if undiluted, they will look like oils.

For wet media, you will need a palette for mixing and a couple of jam jars – one containing water for mixing colour, the other for washing your brushes.

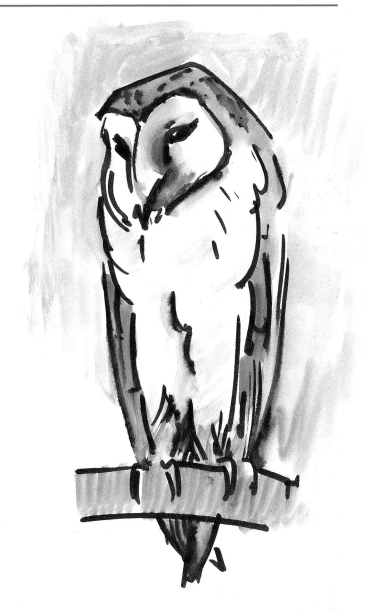

Waterproof ink may be used for drawing the underlying forms, which can be fleshed out with ink wash overlays *(below)*.

This owl *(right)* was sketched in felt-tip pen. When the ink was dry, a wash was applied in areas to create tone and shadow.

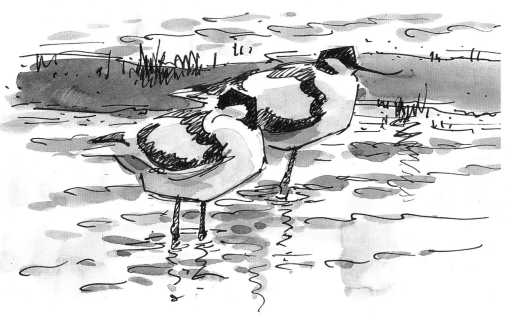

**Artist's Tip**

*You can create fascinating results by painting water-based colour over water-resistant wax- or oil-based crayons.*

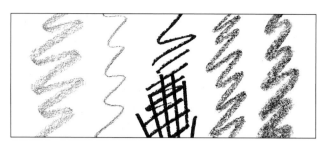

Newsprint is very inexpensive, which makes it good for practising and rough sketching.

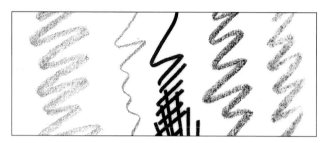

Tracing paper is semi-transparent, so that you can lay it over other images and trace them.

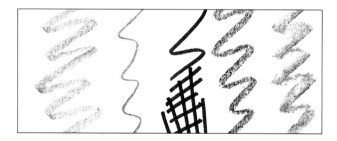

Stationery paper, usually available in one size, has a hard, smooth surface that works well with pen.

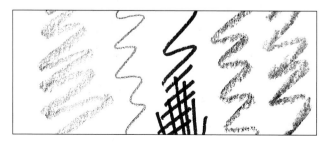

Cartridge paper usually has a slightly textured surface, and is one of the most versatile surfaces.

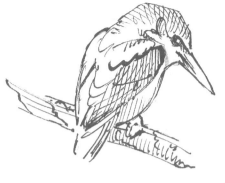

Cartridge paper makes a good partner for pen and ink *(above* and *right)* – these require a relatively non-absorbent surface so that the nib does not snag and the ink does not 'blotch'.

## Surfaces to draw on

You will find out through experience what surface suits your style best, and what suits the medium you are working with. Don't be afraid to experiment with different combinations of media and surfaces; it's exciting to explore the way in which each surface changes the appearance of each medium.

**Watercolour paper** is the most expensive paper. It may be hand- or mould-made, and comes in different thicknesses measured by the weight of a square metre: the thickest, for example, weighs 638g. It is tough and absorbent, consisting partly or wholly of cotton and linen fibres. It will take vigorous drawing and watercolour washes, and is acid-free so will not go brown if left exposed to daylight.

**Cartridge paper**, either cream or white, is the most versatile surface for day-to-day drawing. This can be bought in rolls or sheets.

**Cheap papers** are not to be despised. Brown wrapping paper, for instance, makes an excellent and tough surface on which to work, as does photocopy paper and plain newsprint.

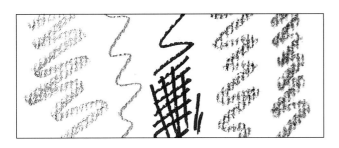

Ingres paper, in various colours and with a lightly ridged surface, is ideal for pastel and charcoal.

Watercolour paper is thick and absorbent, and has a rough surface. It is good for wet media.

Bristol board is stiff and has a smooth finish that makes it a good surface for pen drawings.

Layout paper is a semi-opaque, lightweight paper that is very suitable for pen or pencil drawings.

**Blocks, books** and **pads** are needed for outdoor sketching. Blocks consist of ready-cut and stretched watercolour paper on a card base. Books consist of watercolour or cartridge paper bound with a hard back. Pads are usually made of cartridge paper, spiral-bound or glued. They are available in *portrait* (upright) or *landscape* (horizontal) format.

Paper has one of three grades of surface: *hot-pressed* (which is smooth), *not* (meaning not hot-pressed, i.e. slightly rough) and *rough* (an interesting, textured surface).

Smooth surfaces are best for pen and wash and detailed pencil work. Rougher surfaces suit bold, dark pencil, charcoal and crayon. Pastels and chalks do not take to smooth surfaces because their particles cannot cling to them; they are best suited to tinted pastel paper.

Watercolour papers can often have attractive textures – 'laid' or 'wove' – according to the mould they are made in. This can add enormously to the interest and importance of your work.

Watercolour paper, when dampened, allows a watercolour wash to spread attractively *(below)*.

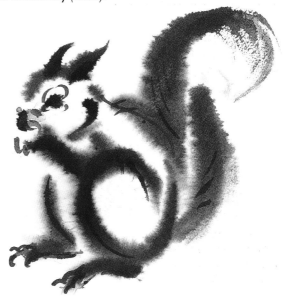

# Choosing the Right Medium

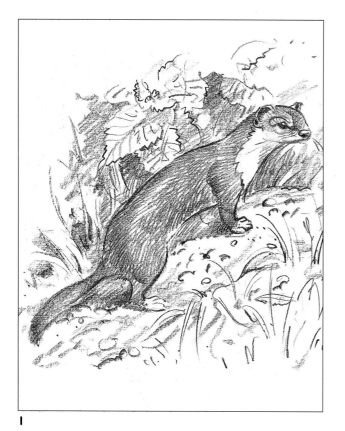

1

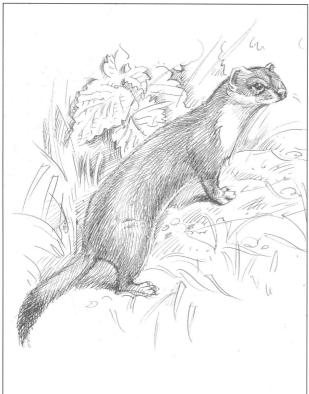

2

It is worth making yourself familiar with the wide range of drawing materials and surfaces available. You will find that the various media are suited to different purposes. Some methods and styles will suit you individually better than others; a combination of media may express the feeling you want to convey.

You may, for example, want to portray the details in an animal, in which case a fine point like a hard pencil will fulfil your aim. Alternatively, you may want to express a sense of flow and movement, or give a more general impression of the animal as a whole. Here, the flowing line from a wet brush will enable you to convey this feeling more easily. To create a sense of mood and atmosphere, the softness of charcoal is ideal.

If you look at the pictures on these pages, you will see that they are of a stoat in the same pose, yet they all look very different, according to the medium that has been used. Ballpoint pen on white card, for example, produces fine, crisp lines which are suitable for analysing fur, eyes, or feet, in detail. This can be compared with brushwork on wet watercolour paper, or with charcoal on textured paper. The softness of these two combinations gives a greater sense of light, movement and mood.

From the examples on these two pages, you can see how, by exploring different combinations of medium and surface and then choosing the most appropriate, you can achieve the effect you want much more quickly.

1 Soft pencil on cartridge paper
2 Ballpoint pen on white card
3 Dip-pen and ink wash on thick cartridge paper
4 Brush-pen on wet watercolour paper
5 Charcoal on textured paper
6 Watercolour on watercolour paper

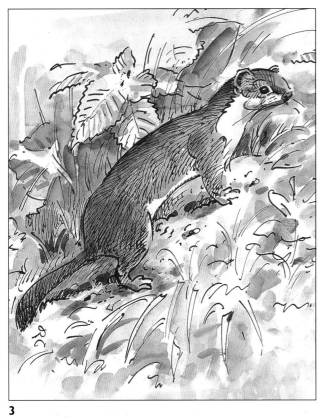

**3**

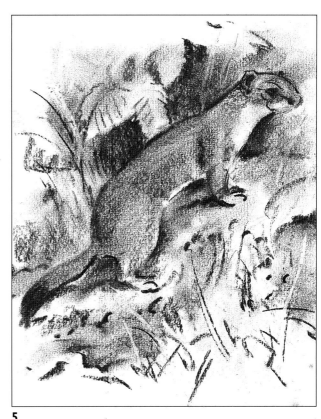

**5**

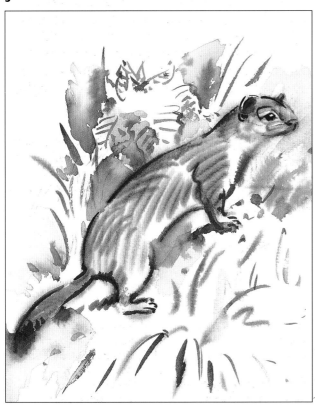

**4**

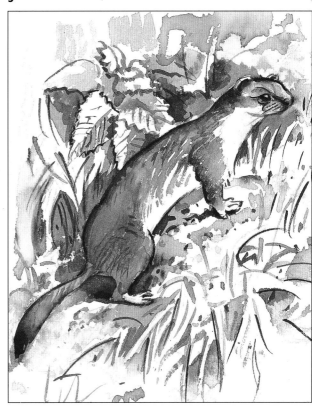

**6**

# Looking at Character

Animals and birds have evolved to make the most of the niches they occupy in the environment. Each activity – swimming, flying, running, grazing or hunting – has defined the form and shape that their bodies have taken, and has given them their own particular 'character'. This section aims to help you to define that character, and to show you how to capture the essence of each animal or bird on paper.

## Gulls and owls

On these pages are two contrasting species of bird, a black-backed gull and a barn owl. The owl has a big head and large, forward-facing eyes for hunting at dusk. It holds itself upright, with its rounded wings drooping behind.

The gull, by contrast, has a small head and longer bill, and long, narrow wings for gliding along breezy seashores. It holds its body horizontally.

## Drawing a gull

The gull's folded wings form a long triangle. When alert, its long neck forms another one and the wedge-shaped head suggests yet one more. This simple format summarizes the gull's shape, which can then be elaborated by defining the feather masses. Details derived from your sketchbooks or photographs can be added, such as the small eye, the knobbly 'knee' joints and the hatchet-like beak.

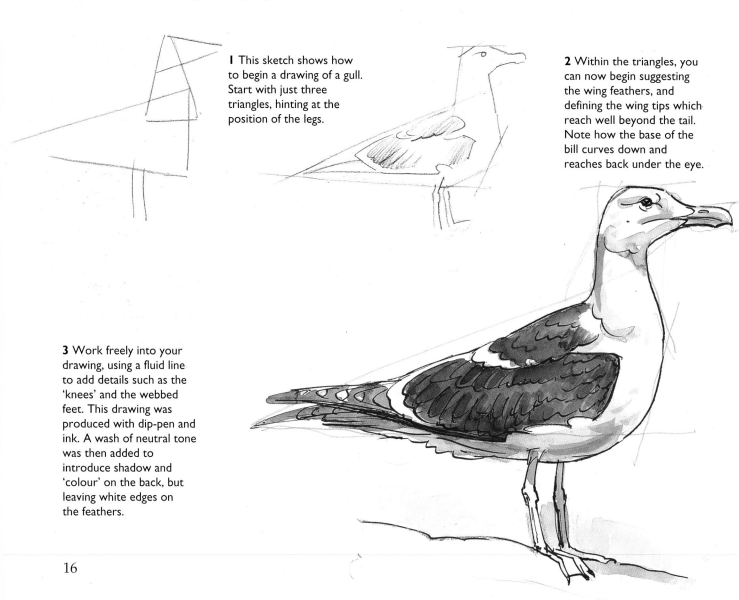

**1** This sketch shows how to begin a drawing of a gull. Start with just three triangles, hinting at the position of the legs.

**2** Within the triangles, you can now begin suggesting the wing feathers, and defining the wing tips which reach well beyond the tail. Note how the base of the bill curves down and reaches back under the eye.

**3** Work freely into your drawing, using a fluid line to add details such as the 'knees' and the webbed feet. This drawing was produced with dip-pen and ink. A wash of neutral tone was then added to introduce shadow and 'colour' on the back, but leaving white edges on the feathers.

## Drawing an owl

For the barn owl, nothing could be easier than to start with a circle to represent the bird's head, and two lines from either side of it, meeting below, for the wings. The design is assisted by the helpful shape of the heart-shaped facial disc which can be added immediately to the circle. Again this simple shape can be worked into by carefully describing feather masses, and details such as the large eyes, the beak, legs and feet.

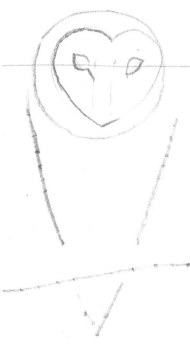

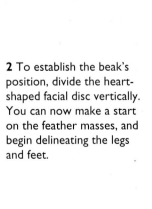

**1** Begin your owl by lightly drawing in a circle for the head and lines for the wings. These can be erased or drawn over later. A horizontal line can be used to establish the position of the eyes, and the slant of the perch suggested to 'place' the bird in its setting.

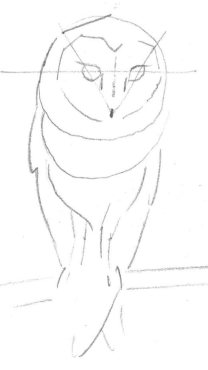

**2** To establish the beak's position, divide the heart-shaped facial disc vertically. You can now make a start on the feather masses, and begin delineating the legs and feet.

**3** To complete the drawing, details such as the toes may be added, as well as tone to suggest shadow. Feather edges and feet may be strengthened, and the eyes darkened, leaving a white area within them to suggest the highlights.

**The blackbird**

The familiar blackbird makes itself useful to us by consuming quantities of insect pests and fallen fruit. Its shape is sleek and aerodynamic. The head fits snugly into the body and extends into the long tail, which is raised when the bird is alarmed.

**Drawing a blackbird**

The simplest approach to drawing the basic shape of the blackbird is the time-honoured device of an egg-shape for the body and a smaller 'egg' for the head, overlapping the body at the neck. The line of the tail can be found by dividing the body longitudinally. The legs emerge from just behind the belly. Although the bird will move its head and point its bill in many directions, it usually carries it a little upwards, which gives it its jaunty look. The eye is situated above the bill and near the mouth opening.

**The blue tit**

These attractive little birds are regular visitors to the garden feeder, so there are plenty of opportunities to draw them.

The heads of smaller birds are larger in proportion to their bodies than those of bigger birds. Care with this aspect will give your drawings a correct sense of scale. The same 'two-egg' principle used for the blackbird applies to drawing their basic forms, but you can let the head overlap the body more – making them even more compact than the medium-sized blackbird.

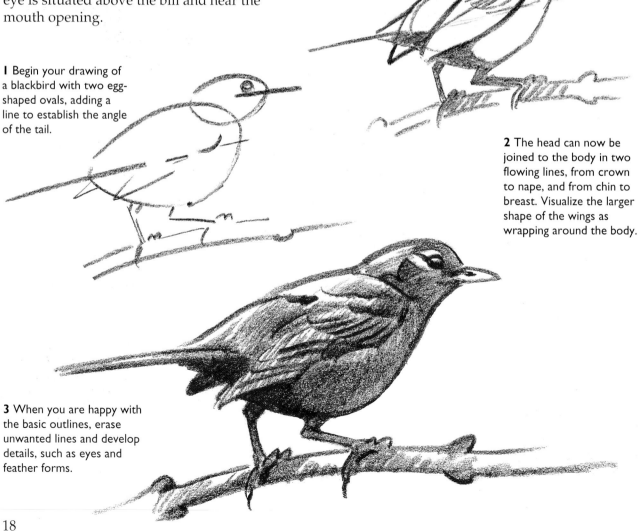

**1** Begin your drawing of a blackbird with two egg-shaped ovals, adding a line to establish the angle of the tail.

**2** The head can now be joined to the body in two flowing lines, from crown to nape, and from chin to breast. Visualize the larger shape of the wings as wrapping around the body.

**3** When you are happy with the basic outlines, erase unwanted lines and develop details, such as eyes and feather forms.

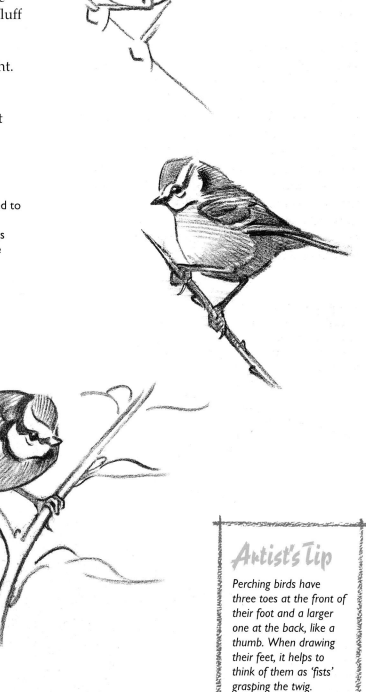

### Drawing a blue tit

The blue tit has marked colour divisions in its plumage that not only characterize it but also help us to sketch it. Its head can be seen as mainly white, with a blue top-knot and a stripe running through the eye to the small bill. The cap is slightly crested and the neck feathers fluff out, giving its circular form a bull-necked appearance – thus the line from crown to primary feathers appears to be almost straight.

Its rear claw is slightly longer than the front ones and trails down. The foot from the front can be rendered with four pencil strokes.

Compare the ovals used to build up the blue tit in these charcoal drawings *(right)* with those in the blackbird opposite.

Seen from the front, the basic shapes of the blue tit's head and body become more circular, overlapping concentrically *(above)*.

*Artist's Tip*

*Perching birds have three toes at the front of their foot and a larger one at the back, like a thumb. When drawing their feet, it helps to think of them as 'fists' grasping the twig.*

## Ducks and herons

Unfolding spirals, wave motions and whiplash lines all convey a visual sense of rhythm. If you can capture something of this rhythm, it will literally 'animate' your drawings and give them a sense of life. The mallard duck and the grey heron, both inhabiting the same wetlands, exemplify this rhythmic flow of line.

## Drawing a mallard

These unfolding spirals are especially obvious in the body of the mallard. On this page, you can see how the expressive character of such a bird can be composed from curving lines. The essence of its outline can be simplified into two basic shapes – a question mark for the head, and a tear-drop shape for the body.

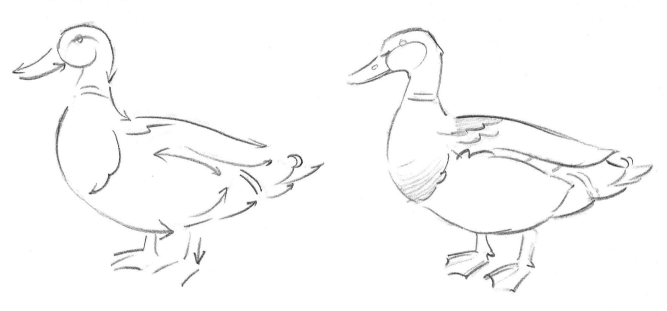

**1** The mallard's body is a series of spiral sweeps, starting from the eye and going around the cheek, under the chin, over the crown, and down the back of the neck. This is echoed by a wider sweep over the breast, under the belly and around the flank, expressing the fullness of the bird's form. The back, too, curves subtly off towards the tail. The legs are set back slightly.

**2** The bird's plumage divides into convenient coloured areas. Building these up will help you to understand feather masses.

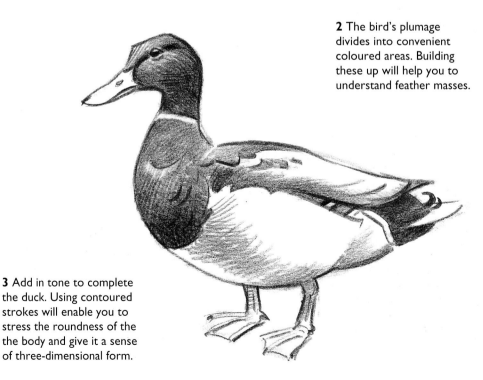

**3** Add in tone to complete the duck. Using contoured strokes will enable you to stress the roundness of the the body and give it a sense of three-dimensional form.

**Drawing a heron**
Since it is a fish-eating bird, the grey heron's beak is like a spear, unlike the spoon-bill of the dabbling duck. It has a long, elegant neck and long legs for wading, and remains motionless for minutes, which makes it a good model.

In its neck, the heron has a remarkable vertebra which gives it extra impetus when it snaps forward at lightning speed to catch a fish. This creates the broken S-shape of its neck – an extra element to introduce into its rhythmic form.

**2** Begin to build up tone, using your strokes to suggest contours of folded wings. More detail may then be added to joints and toes.

**1** Begin the heron's body by establishing the dynamic S-bend of the neck, fitting the small head on it, and lining up the bill with the eye. You can then add fluid, downward-curving lines for the body.

*Artist's Tip*

*The rhythmic lines in a duck or heron correspond to the way in which we naturally move our hands as we draw. Exploit this natural tendency by keeping your wrist loose and flexible and your hand relaxed, and you will find that you are automatically producing the kind of flowing, curving line you require.*

**3** Complete the details of nostrils on the beak, the highlight in the eye and the black crest on the head. Softer tone may be used to create shadow under the chin and on the legs. Further refinement of feather detail will add to the solidity of the bird.

21

**The red squirrel**
Unlike the comparatively ponderous badger opposite, the red squirrel is almost fairy-like as it runs up tree trunks and skitters through the twigs and branches, balanced by its long tail.

**Drawing a red squirrel**
When the animal is at ease, its tail is curled up behind it like a question mark. The squirrel seems to be composed of a series of unwinding spirals, starting from its folded haunch and paw and travelling down and around over its back and into its tail. Once you have grasped this main shape, you can work into the drawing with more detail.

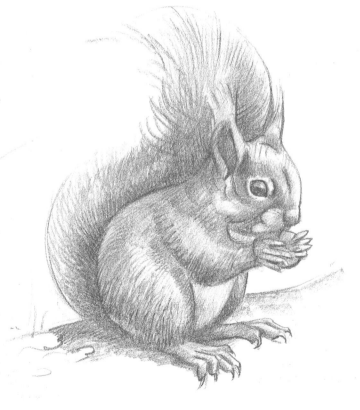

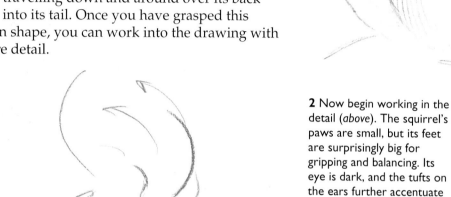

**2** Now begin working in the detail (*above*). The squirrel's paws are small, but its feet are surprisingly big for gripping and balancing. Its eye is dark, and the tufts on the ears further accentuate its linear curves.

**3** To suggest a sense of roundness and solidity, allow your pencil lines to follow the form of the body (*below*). Details of eyes, ears, nose and paws can be gleaned from drawings in your sketchbook.

**I** To begin your drawing of a squirrel, sketch in the main outlines lightly. Notice the line spiralling out from the haunch and over the back. Note, too, how the tail closely follows the back, then curves away and out in counterpoint to the lower body.

## The badger

A member of the same family as otters and stoats, the badger is characterized by rhythm and grace. It is a much heavier animal than others in the group but, like all its family, it has short legs and a long body. Its thick, coarse, hairy coat hides its limbs and disguises body movement. Its distinctive shape – the long muzzle, blunt nose, large forehead and long body – gives it a lumbering quality. It has large front claws for deep burrowing and a black and white striped face for night recognition.

## Drawing a badger

Although details such as long hair may obscure the animal's body or features, it is important that you try to look for the larger underlying shapes. Exploratory pencil drawings are essential to developing an understanding of form.

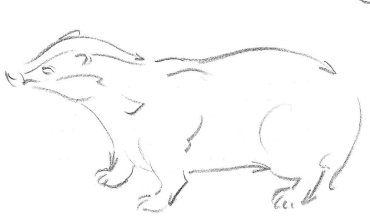

**1** Work out the pose you want in pencil first, emphasizing the forward lunge of the badger's body and the blunt muzzle.

**2** You can then work strongly into your drawing with charcoal pencil which creates a dark tone instantly. Note how the pale hairs of the badger's coat have dark tips, which outline the fur masses and seem to radiate downwards from the back.

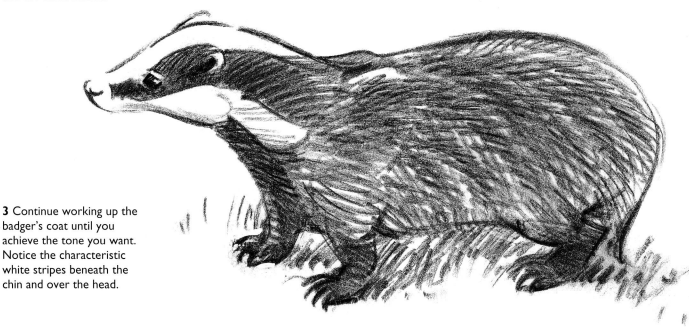

**3** Continue working up the badger's coat until you achieve the tone you want. Notice the characteristic white stripes beneath the chin and over the head.

**The otter**
Like its cousins, the stoat and the badger, the otter has a long body and short legs. Unlike them, however, it has taken to the water; its long tail and webbed feet have developed to steer and propel it as it plunges after fish. It is an intelligent animal and spends much of its time in play.

**Drawing an otter**
The full length of the otter's body and neck is revealed when it stands, propped up by its 'rudder' tail, to look around the landscape, as shown in the group of pictures on this page.

In this pose the sides of its body are virtually parallel and the tail is at a right angle which makes an easy shape to see, and thus to draw. The small fore-limbs are about one third down its body, and its folded legs occupy about a quarter of the body length. Its head is turned slightly towards us and tilted up, emphasizing its flatness and showing us a view of its muzzle and chin. The small eyes and ears are in line with the nostrils.

In the finished standing pose, its fur is damp rather than wet. This results in a radial pattern which emphasizes contour and delineates roundness and form. The lines of the fur also carry the eye down the flow of the body.

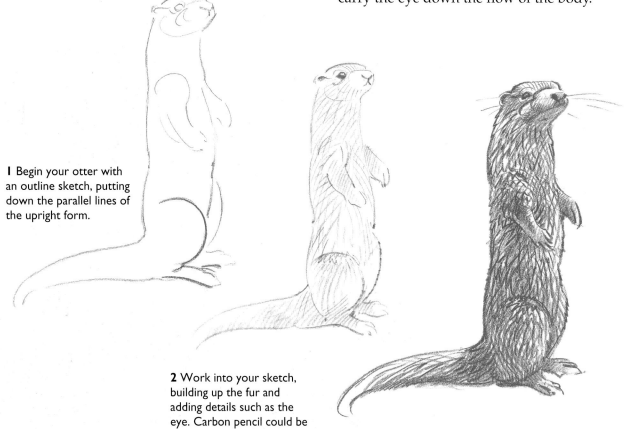

**1** Begin your otter with an outline sketch, putting down the parallel lines of the upright form.

**2** Work into your sketch, building up the fur and adding details such as the eye. Carbon pencil could be a good medium to use because of its granular depth of tone.

**3** To complete the drawing, build up the forms of the round lower limbs, being aware of the way in which they link into the tail, which curves out and around, away from the otter's body. Work over your drawing to bring out the spikes of fur, spiralling and criss-crossing over the body contours, and complete any unfinished details of the head.

### The roe deer

A graceful inhabitant of fields, scrub and woodland, the roe deer is a browser of vegetation. For this purpose, it has a heavy muzzle and long legs. It will vanish silently into the undergrowth or bound away if surprised, which is rare for it has a large, dark eye set high on each side of the head for all-round vision and large ears – all especially useful at dusk. In the autumn the stag develops antlers, protected by a 'velvet' covering.

### Drawing a roe deer

In the drawings below, you can see a roe deer in an alert but casual pose. The first sketch shows the essential lines which characterize the animal – the high carriage of the head on its long neck, and the solid body for digesting its diet. The hind legs set well back for maximum stride, and the strong hind-quarters suggest that the animal might leap away at any sign of danger.

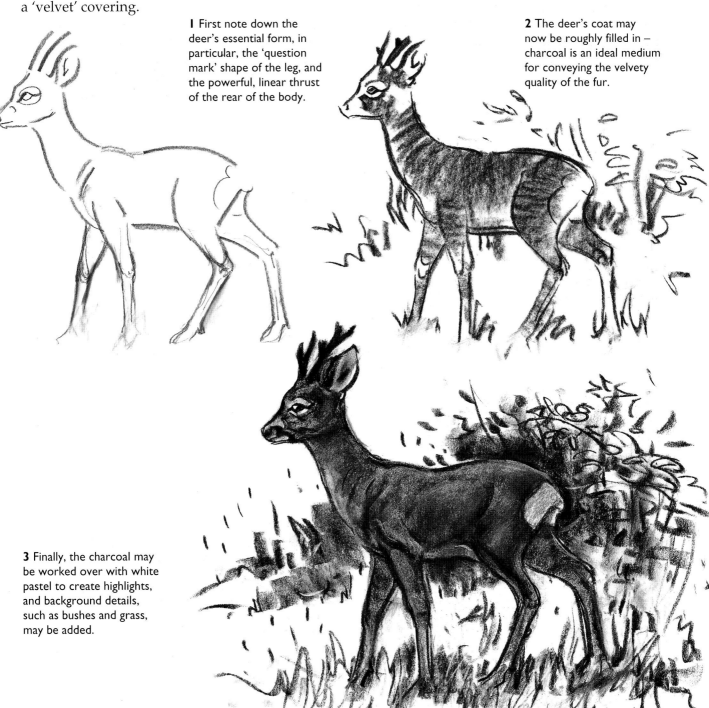

**1** First note down the deer's essential form, in particular, the 'question mark' shape of the leg, and the powerful, linear thrust of the rear of the body.

**2** The deer's coat may now be roughly filled in – charcoal is an ideal medium for conveying the velvety quality of the fur.

**3** Finally, the charcoal may be worked over with white pastel to create highlights, and background details, such as bushes and grass, may be added.

# Looking at Features

On these pages are a few facial features from the infinite variations the animal world presents to us. Take a closer look at them and compare their differences, and similarities. Each of the finished drawings is accompanied by an earlier sketch, showing how the feature may be broken down into its basic shapes.

**Eyes**
Their shape and colour may vary, but eyes are almost universal in their structure. Both birds and mammals have an eyeball consisting of a cornea, a pupil and an iris. The iris changes the shape and size of the pupil according to the amount of light available.

Owls have eyes mounted to face forward – this is to help them to assess the location of their prey. By night, they can expand the pupil to fill the eye in order to see as much as possible. By day, the pupil contracts to reveal, in the case of this long-eared owl *(right)*, its rather wild-looking iris. When drawing an eye, remember to leave part of the area white for a reflected highlight.

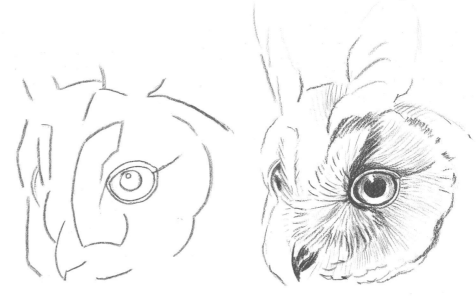

Deer are not hunters, so they must keep a good look-out for predators. Their eyes are large, placed high and on the side for all-round vision. When the animal relaxes, it may semi-close its eye, producing a half-moon shape when the eye is viewed from the front *(right)*. Notice how the bones of the skull have developed to house and protect the eye.

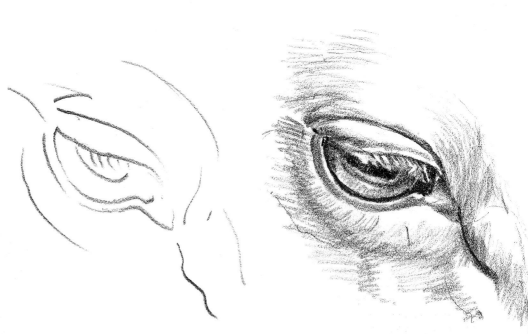

## Ears

The ears of birds are concealed under their feathers, but mammals have developed convoluted, trumpet-like structures. Those that are likely to be preyed upon have large ears. They are alive to the smallest nuances of sound – a high-pitched squeak or a crushed leaf can warn of danger.

For the artist, the shapes these organs make assist in giving each animal its own particular character. The drawings here show what to look for – how to construct the ear, and how to give it its distinctive look.

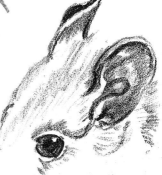

The wood mouse has huge ears in relation to its small bulk *(above* and *right)*. They are round and relatively simple in form.

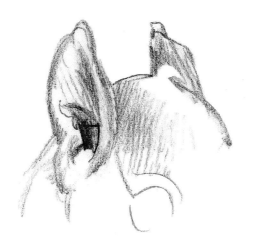

The squirrel's ears *(far left* and *left)* are leaf-shaped and pointed. Seen from this angle, the ear at the back appears to fold over on itself, in a figure-of-eight.

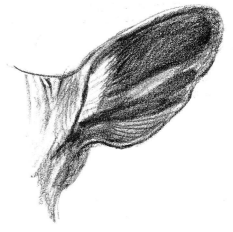

The deer has large, wedge-shaped 'flappers' *(right* and *far right)* that move constantly to focus on and evaluate sounds.

## Noses and beaks

Noses and beaks can vary enormously in shape, as you can see from the drawings here. Nothing could be more different than the noses of the polecat and the fallow deer, for example. The two fish-eating birds – the puffin and the grebe – demonstrate how different beaks can be, even when they pursue similar prey.

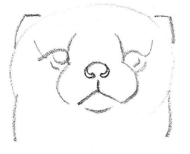 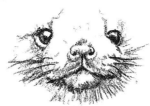

The deer's muzzle *(below and below right)* is bulky and square. The nostrils, again teardrop-shaped like those of the polecat, are large to scent and to take in air, and the jaws are large for cropping herbage.

The polecat's small nostrils and muzzle *(above and above right)* are typical of the Mustelid family. The nostrils fold under the button nose like two teardrops, and the division in the upper jaw almost links up with them.

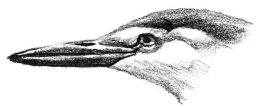

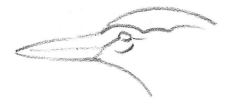 

The grebe catches fish singly to bring back to its young. Its bill is dagger-like, and its head narrow *(far left and left)*. Notice how the eye is linked to the bill.

The puffin's bill is triangular – a simple extension of its chin and forehead *(right and far right)*. The bird is capable of carrying a number of fish crosswise in its beak to bring back to the nest.

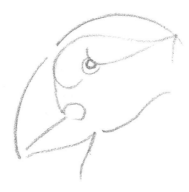 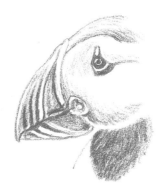

**Feet and claws**

Perching birds have a long hind toe, and three toes at the front, to enable them to grip twigs and branches. Game birds, being mainly walkers, have largely dispensed with the hind toe. They have three large toes at the front, each with two joints; the middle toe is longest.

Mammals have evolved differently. The rabbit, for example, has paws with four toes at the front, the rear one having become redundant. Badgers have powerful feet with long claws for digging, rooting and burrowing. The claws radiate out over the pad. With its modified cloven hoof, the deer walks virtually on tiptoe.

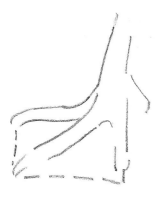

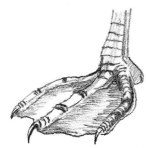

It is easy to work out the way the web on the duck's foot is to be drawn:

simply join up the three toes at the tips *(above left and above).*

When drawing rabbits' feet, you need only hint at the toe divisions as the close fur obscures details *(right and below).*

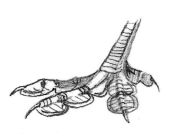

The bone structure of a coot's foot *(left)* is similar to the duck's, but the bird has developed a different means to propel itself through the water. Its toes are palmate, equipped with individual paddles which give them the appearance of leaves with a stalk. Remember that the far 'leaves' will be hidden when viewed from the side.

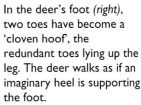

The fur on a badger's foot *(left)* is dark but glossy, so there is an arc of highlight on it over the toes.

When spread, a bird's foot forms a 'stand' to support it, as in the foot of this perching bird *(right).*

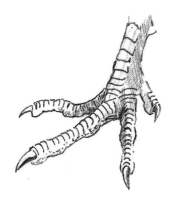

In the deer's foot *(right),* two toes have become a 'cloven hoof', the redundant toes lying up the leg. The deer walks as if an imaginary heel is supporting the foot.

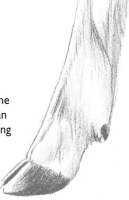

# Structure and Form

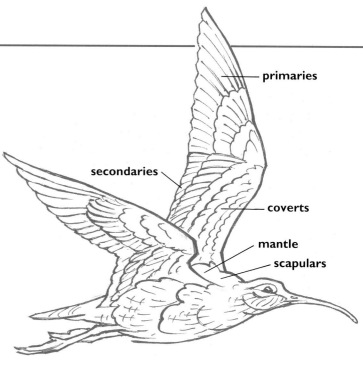

The process of drawing birds and animals is made a lot easier if you understand something of their physical structure.

**Wings and feathers**

Birds have individual feathers that are laid over each other, like roof tiles, to resist wind, rain and dust, yet slide open to provide aerodynamic surfaces for instant flight.

Around the head, the feathers are small and close-fitting, and are almost indistinguishable from one another. They get generally larger towards the wing-tips and tail. They fall into recognizable masses, a feature which makes it easier to produce quick sketches, and means that you don't have to draw every feather.

When a bird's wing is folded, the flight feathers – the *primaries* and *secondaries* – slot under the upper wing *coverts*; these then slide under the *scapulars*, which in turn slide under the *mantle*. When closed, the feathers in the tail slip away under the middle and widest tail feather. In flight, the wing feathers are fully extended and the various feather panels are clearly visible.

When drawing a bird in flight, you will find it useful to imagine the wing as a solid shape, like a knife, cutting the air. You can place less emphasis on the feather detail than I have in this pen-and-ink drawing of a curlew (*above*), and more on capturing the lines of feathers that most help the feeling of buoyancy.

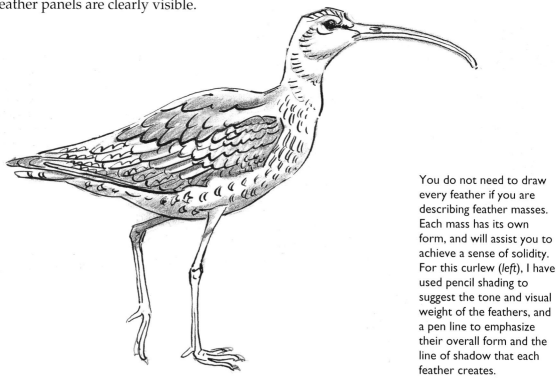

You do not need to draw every feather if you are describing feather masses. Each mass has its own form, and will assist you to achieve a sense of solidity. For this curlew (*left*), I have used pencil shading to suggest the tone and visual weight of the feathers, and a pen line to emphasize their overall form and the line of shadow that each feather creates.

**Birds' legs**

Initial confusion may attach to the bird's backwards 'knee'. A bird's leg works very much like the back legs of most four-footed animals; it is just that we cannot see the thigh and all of the *tibia* (the part of the leg below the bird's real knee) – they are hidden by the flank feathers, as I have shown in the drawing of a wheatear below. What looks like a knee is actually the joint at the top of the *tarsus* – which, in turn, is really an extended foot, the bird's 'foot' being formed from its toes.

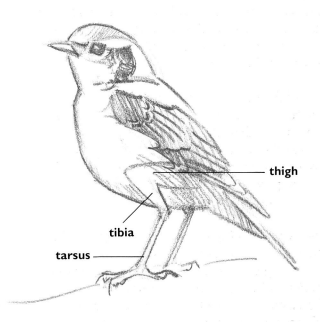

I drew this wheatear (*right*) with a 2B 'clutch' pencil which gives a fine and continuous line. I suggested tone with 'cross-hatching', or overlapping strokes. I have also shown where the 'knee' would be if it were not covered by flank feathers.

thigh

tibia

tarsus

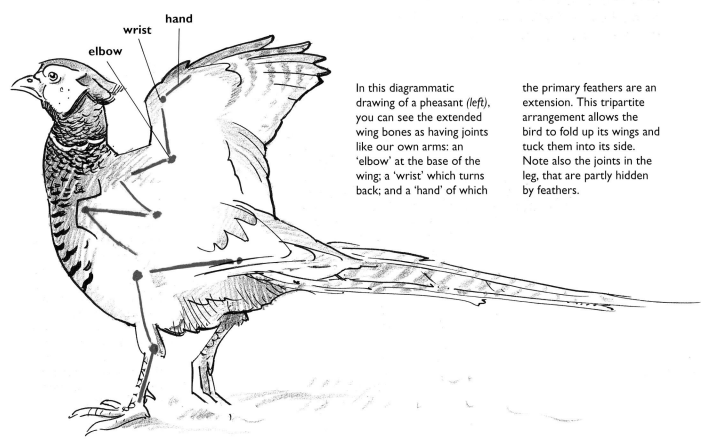

elbow

wrist

hand

In this diagrammatic drawing of a pheasant (*left*), you can see the extended wing bones as having joints like our own arms: an 'elbow' at the base of the wing; a 'wrist' which turns back; and a 'hand' of which the primary feathers are an extension. This tripartite arrangement allows the bird to fold up its wings and tuck them into its side. Note also the joints in the leg, that are partly hidden by feathers.

## Shaped for survival

The appearance of each animal is determined by the niche it occupies in the natural world. Animals divide roughly into hunters and the hunted, and this has a strong influence on the structure of their body.

The deer, for example, is one of the hunted. Forever on the look-out for danger, its main survival tactic is rapid escape. To this end, it has developed long, springy legs which let it flee quickly from any threat. Its nimbleness is further enhanced by the fact that it stands 'on its toes' all the time, like a ballet dancer. The bones of the foot begin higher up, and this accounts for the angle at which the foot joins the ground.

If you study the drawings below, you will see that, as with birds, the bone system of the deer's rear and front legs is tripartite; an angular Z-shape which can fold up or straighten out.

## Suppleness and strength

The elasticity of the deer's body depends on the suspension of its bone structure and the large muscles which control it. The muscles controlling the legs work around the bones, developing into ligaments attached to leverage extensions on each joint. This is particularly noticeable in the rear leg where the animal needs to have most power.

## Adapted for grazing

Because the deer is a grazing animal, its body has a large rib cage to contain two stomachs, a long neck to browse vegetation, and a long jaw with which to chew it.

The redundant toes in the deer's cloven hoof are visible as knobs protruding behind the leg (right). This actually gives a high-heel-shoe effect to the shape of the foot. The two bones leading to the hoof are visible under the hide (far right).

These two drawings show, in approximate form, the disposition of muscles (below left) and bone (below). The bulk of muscle is found at the top of the limbs on the thigh where the strength is needed. Knowledge of this underlying structure will aid your drawing.

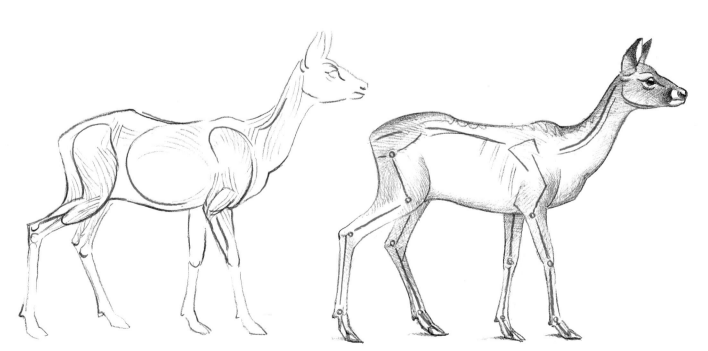

## Short profile

The rabbit is another gourmet of herbage. Being a rodent, it nibbles grass with its front teeth, the upper two being highly developed. It digests these small scissored pieces without much chewing, so its jaw – and hence its profile – is shorter and more compact than that of the deer. It shares the characteristic features of grazing animals – the large eyes and ears with which to detect danger.

## Flexible legs

Like other mammals, the rabbit has a three-part bone articulation in its legs which makes them very flexible. It has short front legs which enable its mouth to reach down to the grass easily. When standing or crouched to graze, it rests on its well-developed feet for stability, its legs folded on each side like a cat's.

When it stands up, its front legs straighten out to support it. Its long feet force it to hop when it moves and to bound when travelling at speed, using its toes.

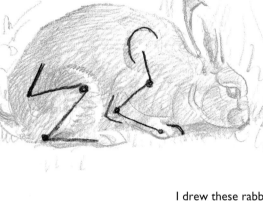

I drew these rabbits with a 9B pencil, using the technique of crosshatching. I began with long strokes curving across the body to suggest contour. I continued with shorter strokes and smaller dashes to suggest the texture of fur, and used more pressure on the pencil to deepen the tone of the eye.

*Artist's Tip*

Use the rhythmic Z-shape of a mammal's leg as a useful way of introducing a sense of movement into action poses.

# Proportion

To produce convincing drawings of birds or animals, it is essential to get their proportions right – the way in which the different parts of the body relate to each other in size and shape. Although, in reality, proportions remain constant, they may *appear* to alter depending on the artist's viewpoint. This is all due to an illusion known as *foreshortening* – the telescopic effect that occurs when you look along an object from behind or in front, rather than from the side.

### The effects of foreshortening

On this page, I have used the stoat to illustrate how foreshortening affects proportion. Because it is not always easy or convenient to draw from a live animal, these studies were based on a stuffed specimen, of the kind available for reference in museums.

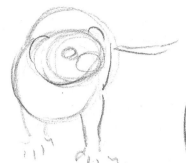

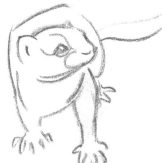

Any cylinder, as it turns towards us, becomes compressed in shape. In this foreshortened front view, we can see the stoat becoming a series of concentric circles. Viewed from the front, the head and 'bib' obscure most of the body, and the front legs and feet dominate.

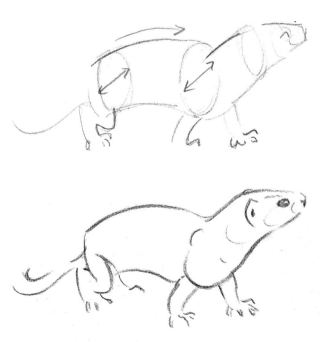

These drawings were done quickly in conté pencil, which produces a charcoal-like textured line. Side-on, the stoat presents us with a body shape that you can visualize as two long cylinders (*above*).

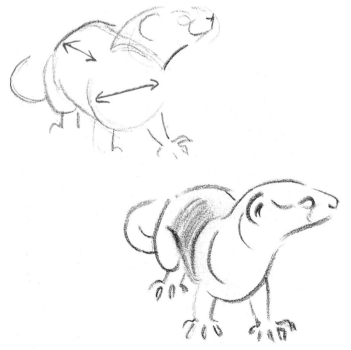

In this three-quarter view, the body cylinder is only partly foreshortened. Seen from this angle, the Z-bend of the rear leg is not visible and is reduced to a knee bulge instead, with the foot projecting beneath.

## Changing shapes

Many birds, such as the duck family, have round bodies and heads. The male tufted duck – in the foreground of the drawing at the bottom of the page – is a glossy black, relieved by well-defined, white flank panels. These fold around the body, half covering the wings. The female behind him shows the high forehead typical of the diving ducks. From the front view, we can see the prominent cheeks on either side of the bill – the eyes have all but disappeared.

From the side, a duck's body looks almost fish-shaped. When the bird swims towards us, however, the shape becomes compressed – a foreshortened, wraparound effect. The wing tips and tail are concealed from us, and the breast area takes up most of the body shape.

As these sketches (*right*) show, I began building up the foreshortened front view of the head with a figure-of-eight line, adding the pyramid-shaped bill. As the head turns, the three-quarter view reveals the eye and shows the full shape of the bill.

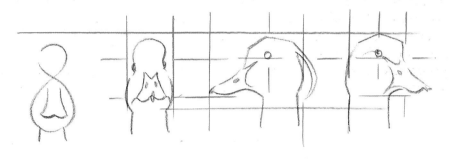

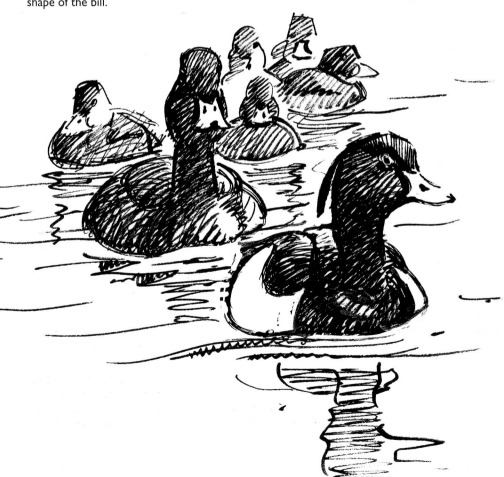

All the ducks in this drawing (*left*) are swimming towards the viewer, and hence have foreshortened bodies. I have, however, used a variety of head positions. This helps, especially with the ducklings, to convey the jerky character of their movements. I sketched the birds quickly in pen line, using a fibre-tipped fountain pen. This gave me interesting variations of thick and thin lines.

### Looking at heads

Whether we are looking up or down at a bird or animal, perspective plays its part in defining shape and proportion, and in determining the positioning of individual parts in relation to each other. I have illustrated how this works with various studies of otters' and rabbits' heads.

### Placing of features

In the case of the smaller mammals, we usually view them from above, which means that the perspective lines will slant up towards us – rather than downwards – as they converge towards the 'horizon'.

You can see the effects of this in the otters' heads at the bottom of the page. When viewed face-on, the otter's ears and eyes are almost level, so that they fit into the section above the muzzle. When seen in three-quarter or side view, however, the perspective changes, so that the further eye lies higher up the head than the nearer one.

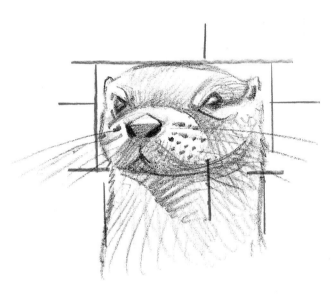

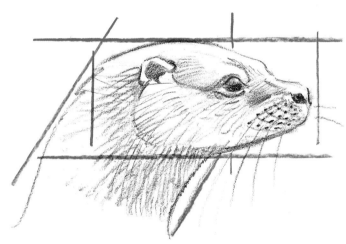

The rectangle I have drawn around this otter's head (*above*) demonstrates the proportion of height to length. I've marked off a line for the eye which, in this view, shows it to be near the nose.

This side view of an otter's head (*above*) has none of the compressed foreshortening of the head on the left.

We usually look down on swimming otters (*below*). When they are moving directly towards us, their eyes are level. When turned sideways, perspective lines rise to meet the horizon so that the far eye and ear will be higher than the near ones.

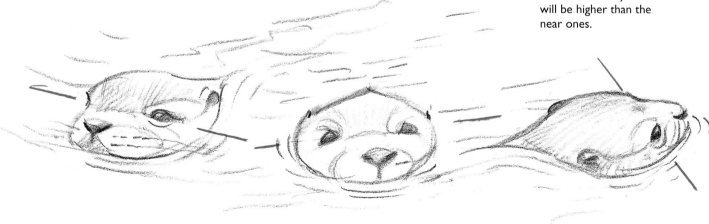

## Prominent features

The drawings of rabbits' heads below again demonstrate how radically perspective and foreshortening can alter shape, and the relative placing of features. Notice, too, how different parts become more or less prominent, depending on where they are viewed from.

Seen from the front, the rabbit's muzzle is prominent, but, when the animal turns its head to the side, the cheek appears larger and assumes greater importance. Seen from above, the rounded forehead dominates.

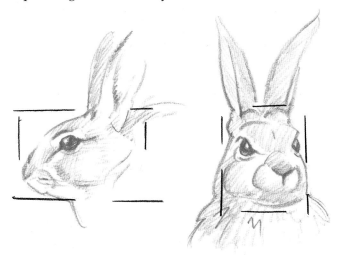

From the side, the rabbit's head presents a full triangular shape *(far left)*; in the front view *(left)*, the muzzle is compressed and appears proportionately larger; while from the rear *(right)*, it becomes so foreshortened as almost to have disappeared.

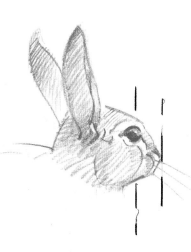

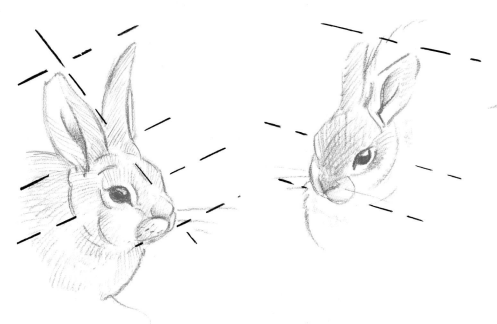

These three rabbit heads *(above)* show how perspective affects the relative position of features such as eyes, ears and nose, depending on the onlooker's viewpoint.

*Artist's Tip*

Young animals have different relative proportions – the eyes being larger, and ears and noses smaller than their adult counterparts.

# Light and Shade

Once you understand how light falls on birds and animals, you can create atmosphere and mood. Light cast from the side, for instance, suggests evening and tranquillity; strong sunlight can bring out solidity so that your images jump from the page.

## Light direction

When you start your drawing, you should first decide what direction the light in the picture is coming from. The studies of an avocet below show how a different light direction affects the mood of the finished drawings. Notice that the parts nearest to the light source are the brightest; as the light glances away over and under the body, the form gets darker, with the darkest areas underneath.

## Variations in light and shade

In the midday sun, the bird's upper parts will be brightest, and the shaded areas will progressively darken under the wings, tail and body. If a bird is mostly white, however, like the avocet, it may reflect light from the ground, which will lighten the tones on the underparts.

Plumage colours, and sometimes glossy feathers, make the patterns of light and shade quite complicated. Take your sketchbook with you when you go out, to note all the variations.

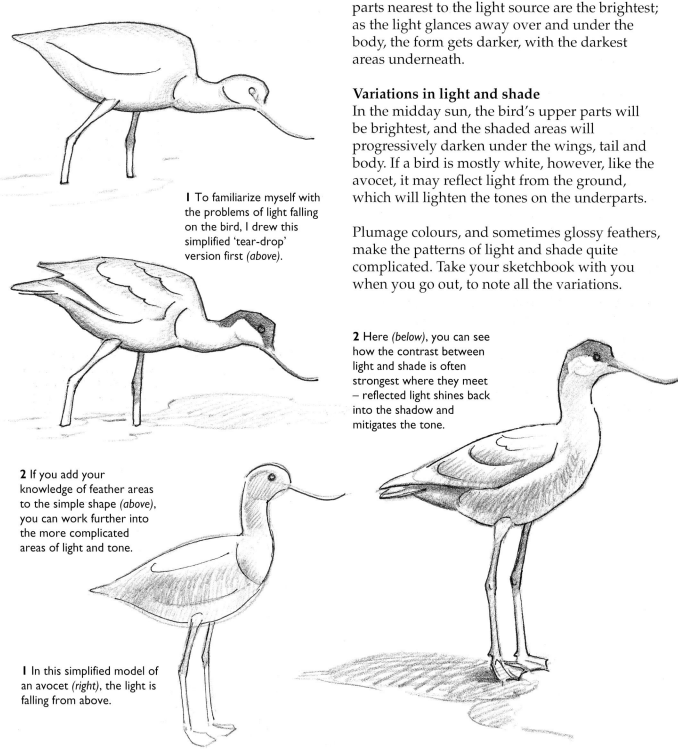

**I** To familiarize myself with the problems of light falling on the bird, I drew this simplified 'tear-drop' version first *(above)*.

**2** If you add your knowledge of feather areas to the simple shape *(above)*, you can work further into the more complicated areas of light and tone.

**I** In this simplified model of an avocet *(right)*, the light is falling from above.

**2** Here *(below)*, you can see how the contrast between light and shade is often strongest where they meet – reflected light shines back into the shadow and mitigates the tone.

## Light and shade on fur

When you come to draw mammals you can see that the same principles apply to them as to birds. This is complicated, of course, by the varied textures of fur – glossy or rough, long or short. If light glances along the fur, its tone is lighter. If the fur is raised, as it often is on folded limbs, then the light disappears into the fur and the effect is dark – you can observe this on your own domestic tabby.

The fox below is lit from behind and above. Again you can do a simple study to work out the main tonal areas. The study reveals how the neck fits the body, how the ears will take shadow and the way in which they, in turn, cast shadow on the forehead. The darkest areas are under the tail and legs where there is little reflected light. The fox's underparts tend to be lighter and its 'bib' is white, so there is opportunity to include reflected light which will give greater luminosity to your drawing.

In the drawing of the vole, the most interesting area is the head where the big ears take the shadow, the cheek is lit up, and the large spherical eye casts its own shadow on the nose. Its fur is glossy – note the shadow under its tail and deeper tones between its rump and the ground it is on.

**I** Even a small mammal like this vole can be divided up into areas of light and dark.

**2** The completed drawing of the vole: note how the shadow beneath it 'anchors' it to the ground.

**I** I began this drawing of a fox by doing a simplified model, in which I blocked in the main areas of light and shade (*below left*).

**2** I finished the drawing with cross-hatched lines to convey the fur's thickness, leaving a highlight along the rump and tail (*below right*).

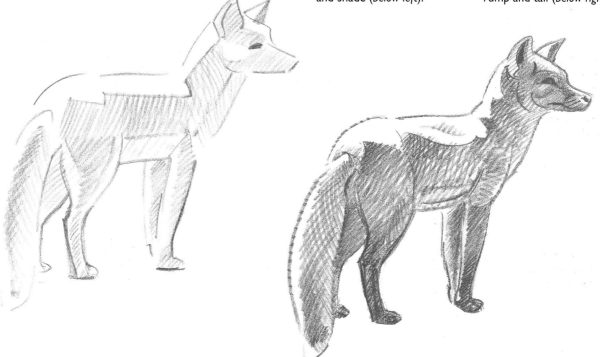

# Texture and Pattern

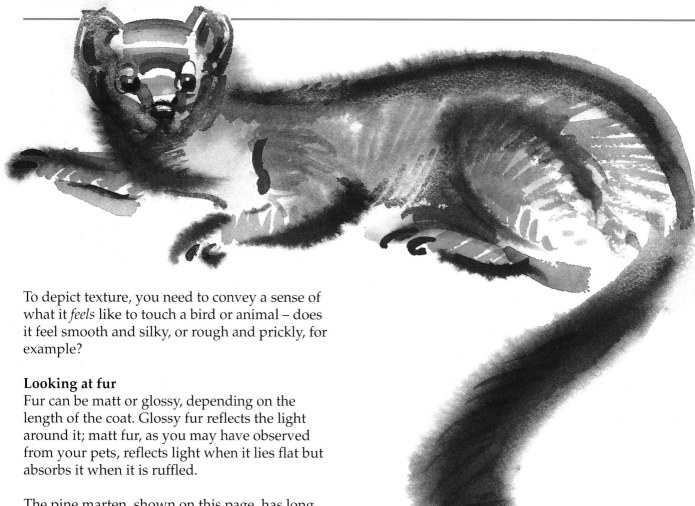

To depict texture, you need to convey a sense of what it *feels* like to touch a bird or animal – does it feel smooth and silky, or rough and prickly, for example?

**Looking at fur**
Fur can be matt or glossy, depending on the length of the coat. Glossy fur reflects the light around it; matt fur, as you may have observed from your pets, reflects light when it lies flat but absorbs it when it is ruffled.

The pine marten, shown on this page, has long, fluffy hair along its body, limbs and tail. The darkness of tone along its back is matched by that of the hairs raised on end when the limbs are folded. The light disappears into the hair. On its head, the fur is glossy and short, and appears dark or light depending on the growth direction.

When you have decided what 'kind' of fur you are dealing with, you need to choose materials that will produce a similar effect. To create the silky-soft look of the marten's coat, I used a watercolour wash, with several brushes: the chisel, or square-tipped, the point, and a 'rigger' or 'liner' brush, which gives long, fine lines and is very useful for making the gestural rhythmic curves I needed here.

Pine martens are rarely seen – this is where it is useful to tape any video footage from wildlife programmes.

To do these drawings *(above* and *below)*, I worked from a number of photographs. I did some careful pencil drawings beforehand to work out the final poses.

Before beginning the finished pieces, I damped the surface of the 'not' watercolour paper. I mixed up a wash of neutral colour (Payne's Grey would do), and made sure that my brush was fully charged with paint before each stroke. I controlled the spread of paint in some lines by mixing it with gum arabic instead of water.

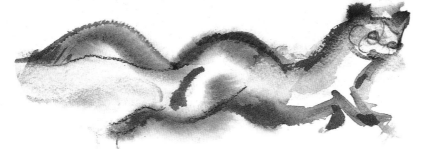

**Depicting spines**

To look at spines closely is like examining a magnified area of normal fur, and it shows some of the same characteristics. The hedgehog is a very familiar 'spiny' animal: it has evolved its protective coat by combining clumps of hairs (almost as if they had been glued together) into spikes. These can be raised to form a prickly barrier to ward off attack.

On the right, the artist has done a close-up study of these spines end-on. As we look into them, light is absorbed into the coat, as in all up-ended hair. As the light glances over laid-back spines, it is reflected and so the area appears lighter. In the case of the hedgehog, this effect is further enhanced by the pale tip to each spine.

In his sketch of the complete animal below, the artist has conveyed these spotty highlights and dense shadows with a series of pencil marks,

some of which are large dots of tone along and under the side. He has then used lighter dashes as the eye moves over the animal. The 'skirt' of long hairs is light in tone and he has treated this area with restraint.

In his study of the 'portrait head', the soft pencil demonstrates the wide variety of possible textures of eye, hair, hide and bristle. The eye is glossy and deep, the hair around it conveyed with short light strokes, and the flow of spines over the back consists of thicker strokes, drawn with heavier pressure.

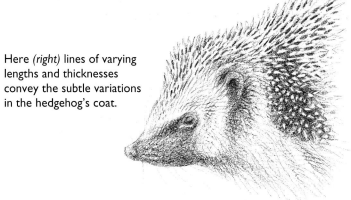

Here *(right)* lines of varying lengths and thicknesses convey the subtle variations in the hedgehog's coat.

**1** This sketch *(below)* captures the hedgehog's essential form.

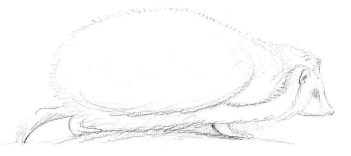

Flecks of white paint have been used to highlight the tips of the spines *(right)*.

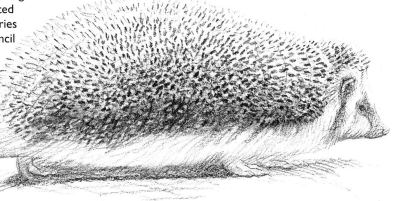

**2** In the finished drawing, the artist has indicated the spines with a series of densely black, pencil dashes *(right)*.

## Looking at pattern

An extraordinary variety of pattern and colour
has evolved in the animal world. Sometimes this
serves to advertise the presence of a bird or
animal – sometimes to conceal it.

Pattern can vary depending on the season. The
great northern diver, for example, has a lead-
grey plumage in winter, but in summer it dons a
smart, black and white, speckled dress. This
advertises to a prospective mate that it is in good
breeding condition. It also has a double effect as
'dazzle' camouflage.

On this page, the artist has investigated the
diver's patterns and how they blend and distort
with the ripples around it, creating patterns on
the water surface. The bird's neck is divided by
a double collar of white, with black pinstripes
linking up with those on the white breast. The
speckles on its back are formed by the white
centres of the feathers – these white dots and
dashes radiating over the back imitate the ripples
among which the bird swims.

**1** The artist has drawn the
image lightly in pencil to
begin the drawing (*below*).
He has worked heavily into
the black areas, taking care
to avoid the white panels in
the radiating feather
pattern.

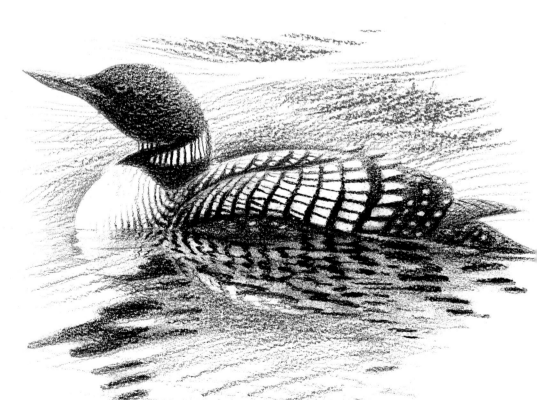

**2** To complete the drawing,
the artist has used graphite
stick and charcoal. By
exploring and exploiting the
qualities of these media, he
has been able to express
the feeling of the scene.
Charcoal captures the
depths of black plumage –
graphite the grey waves
around it.

## Pattern for concealment

Pattern can be used for concealment by enabling an animal to blend in with the background, as, for example, with young deer or female ducks. At other times, concealment is achieved by breaking up the body shape with bold splashes of contrasting tone. This is called 'disruptive' camouflage.

The long-eared owl on this page relies on what is called 'cryptic' camouflage. Its intricate arrangements of speckles and tones aim to imitate the tree bark and dead leaves among which it roosts by day. This disguise is highly effective – the bird remains well hidden, as anyone who has tried to look for it can testify.

Such cryptic patterns are often breathtaking in their harmony and subtlety. Here, the artist has made careful studies of the owl, one of its feathers, and the wing feathers. He has investigated the way in which the individual designs on each feather echo each other to form a repeating pattern.

To convey the richness of the patterns, he has exploited the qualities of a soft 6B pencil combined with a 'not' watercolour paper that has a slightly rough surface.

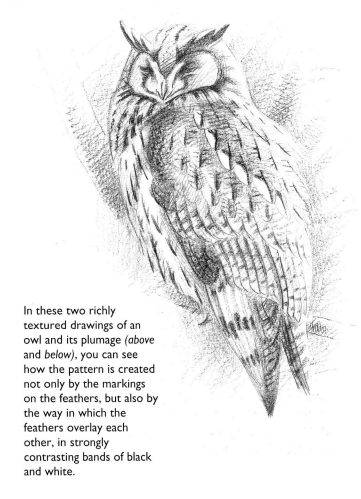

In these two richly textured drawings of an owl and its plumage *(above* and *below)*, you can see how the pattern is created not only by the markings on the feathers, but also by the way in which the feathers overlay each other, in strongly contrasting bands of black and white.

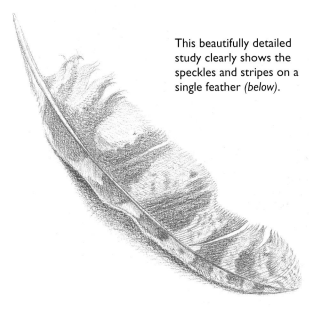

This beautifully detailed study clearly shows the speckles and stripes on a single feather *(below)*.

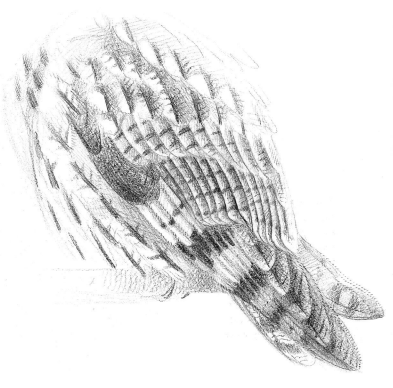

# Behaviour

One of the most exciting activities for the wildlife artist is the opportunity to observe and capture the action and drama of animal behaviour.

On such occasions you will sometimes need to scribble for all your worth to get what you have observed down on paper; at other times, you must just sit, observe and commit as much to memory as you can. You will be surprised how much you can remember and re-create if the situation has impressed you.

**Portraying aggression**
In the drawings on this page, the artist has caught the aggression display of the capercaillie, as it defends its territory. This big gamebird is often brave enough to rush at any human being whom it considers to be an intruder.

In order to appear intimidating, the capercaillie tries to make itself look even bigger – hence the ruffled chin and neck feathers, and the fanned-out tail, like that of its relation, the turkey.

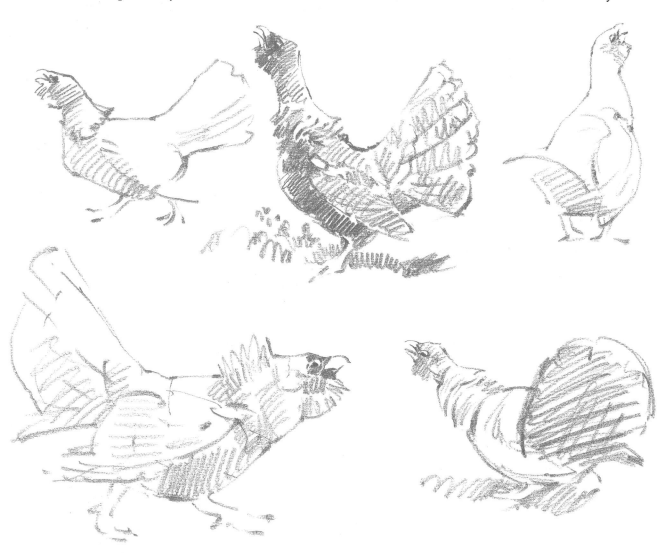

For these sketches, the artist used a soft conté pencil to get line and tone down quickly.

To save time, he has scribbled in areas in some places, and has quickly noted the big shapes, such

as the triangular, side-on forms of the wings and tail, the extended neck and squarish head. From behind,

the tail is semi-circular. The legs and feet are simply rendered as marks and lines, indicating position.

**Sketching a mating sequence**
On this page, the artist has used a 9B pencil to make quick notes on the mating behaviour of a pair of great crested grebes. The softness of the pencil can put down line tones without effort.

Once rare, these grebes are now fully protected, and the species is a common sight on lakes and rivers, where it dives after fish. It is graceful and exotic; in summer it has a crest and a 'tippet' of dark feathers around the neck that can be raised when the bird is alarmed or excited.

In the first drawing, we see the pair swimming towards each other. In the second drawing, the ritual begins: the male rests, his head and long neck coiled back into the body, while the female elicits a display response from him by grunting and rigidly extending her neck over the water-line. After displaying to each other like a pair of book-ends, the male adopts a typically serpentine pose as they are about to mate.

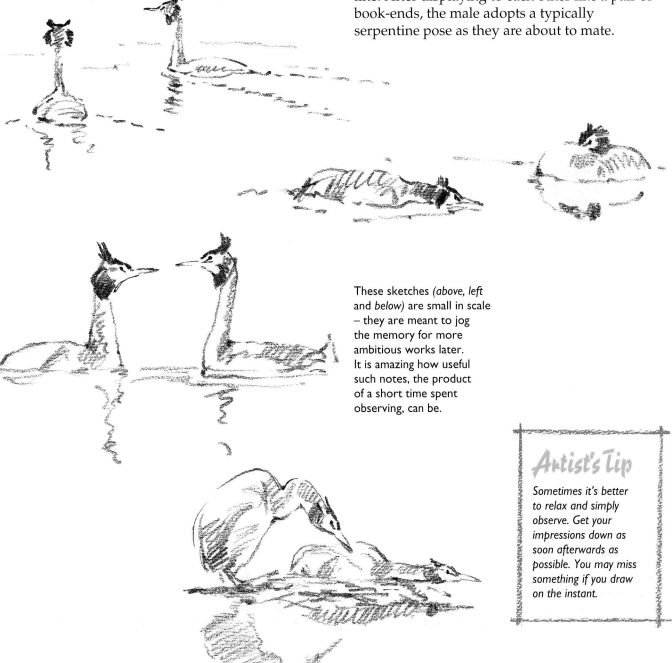

These sketches *(above, left* and *below)* are small in scale – they are meant to jog the memory for more ambitious works later. It is amazing how useful such notes, the product of a short time spent observing, can be.

*Artist's Tip*

*Sometimes it's better to relax and simply observe. Get your impressions down as soon afterwards as possible. You may miss something if you draw on the instant.*

### Capturing a fleeting pose

Few things epitomize the exuberance of spring as much as a party of 'mad March hares' gathered together in frenzied activity to mate in the pastures.

Often it is not so much the males fighting to establish dominance as the females repelling the advances of unfancied males that causes these 'boxing matches'.

To begin with, it will be difficult to capture these exciting but rapidly changing poses. The first thing to note is the one feature that is common to all – the typically upraised ears. Your increasing understanding of animal form will allow you eventually to fit the limbs and their articulations into all sorts of unexpected positions.

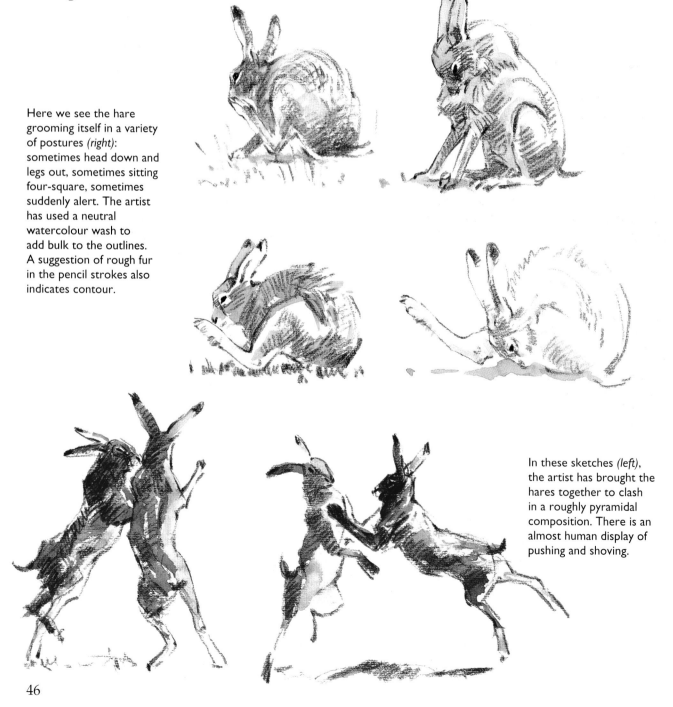

Here we see the hare grooming itself in a variety of postures *(right)*: sometimes head down and legs out, sometimes sitting four-square, sometimes suddenly alert. The artist has used a neutral watercolour wash to add bulk to the outlines. A suggestion of rough fur in the pencil strokes also indicates contour.

In these sketches *(left)*, the artist has brought the hares together to clash in a roughly pyramidal composition. There is an almost human display of pushing and shoving.

### An ideal subject

The fallow deer is larger and bulkier than the roe. Its antlers are long and wide, spreading in area like outstretched wings. It is commonly kept in parks, which makes it a convenient subject for drawing. The studies below were done from sketches and worked up to finished drawings. The artist has used a medium-soft pencil – a 4B – and worked on watercolour paper which adds its own texture to the strokes.

### Looking at grooming behaviour

On the right, we see a study of the animal grooming, in which the leg is brought forward to scratch at its nape. You can see clearly how the the front legs spread to counterbalance the action and to prevent the animal toppling over.

### Looking at mating behaviour

In the autumn, the stag gathers a group of hinds and the rut takes place. In the drawing at the bottom of the page, we see fallow deer pre-nuptials where the stag caresses the doe, testing by scent to see if she is ready to mate.

The artist has used a dark conté pencil on rough paper to express the solidity and textured hide of the fallow deer. He shows a stag resting up during the day, concealed among foliage *(top)*; a deer grooming *(centre)*; and a pair about to mate *(below)*.

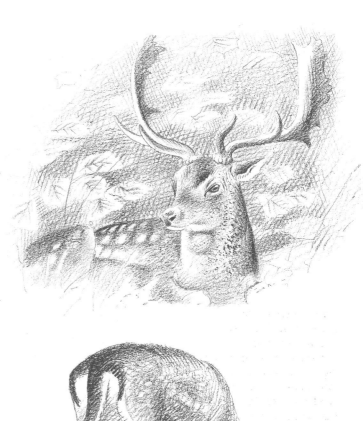

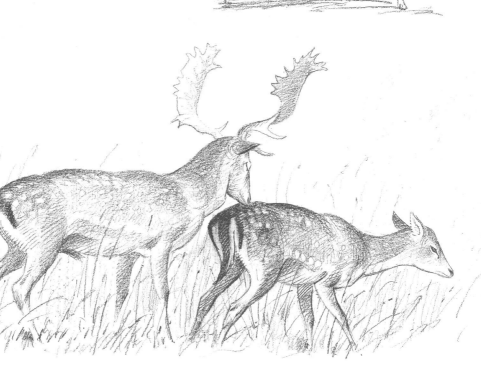

# Movement

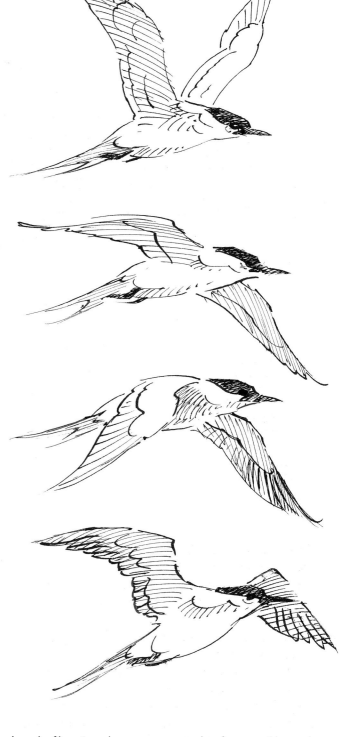

Birds and animals are constantly moving – even at rest, they may engage in grooming, for instance; it is only in sleep that they totally relax. When they are out and about – walking, running, trotting or flying – their movement creates a rhythm. This rhythm is determined by the length of their steps, or the number of wing-beats required to keep them aloft.

## The tern in flight
On this page I have drawn four terns, sea birds that live by diving from a height into the water to catch small fish. Terns have long wings and aerodynamic bodies to make use of the wind. They often need only a few shallow strokes to propel themselves along, whereas smaller birds, such as the sparrow, have to use sheer wing-power to get them from A to B.

## Flight sequence
Each tern demonstrates a stage in one of its millions of wing-beats. As the wings begin the down-beat in the first drawing, we see the feathers of the under-surface pressed close together to create a solid plane. The wings are fully spread in a high V-shape. You can see feather details on both upper and lower surfaces of the wing.

The second bird shows the wing descending and the *pinions* – the primary feathers – bending up with the downward pressure. (The pinions give the flick to the wing that drives the bird forward.) The bird's head rises a little.

The third bird shows the wing at its lowest position, with the pinions bent up. The head is held high. Once more we have views of the upper and lower surfaces. The nearest wing is foreshortened because we are looking along it.

In the fourth drawing we have a view of the wings being raised on the upstroke – ready to return to position one. At this stage, the wing feathers are looser, allowing air through them to reduce upward pressure and to gather air to press on for the downstroke.

I used a fibre-tipped fountain pen with a calligraphic point to draw these terns. The calligraphic nib gives the stark line interesting variations of pressure and thickness. I did a few light pencil strokes first to guide me; I then used whiting-out fluid to erase any pen lines I didn't like. Note how the wing position of the fourth bird means that the arm of the far wing is concealed by the body.

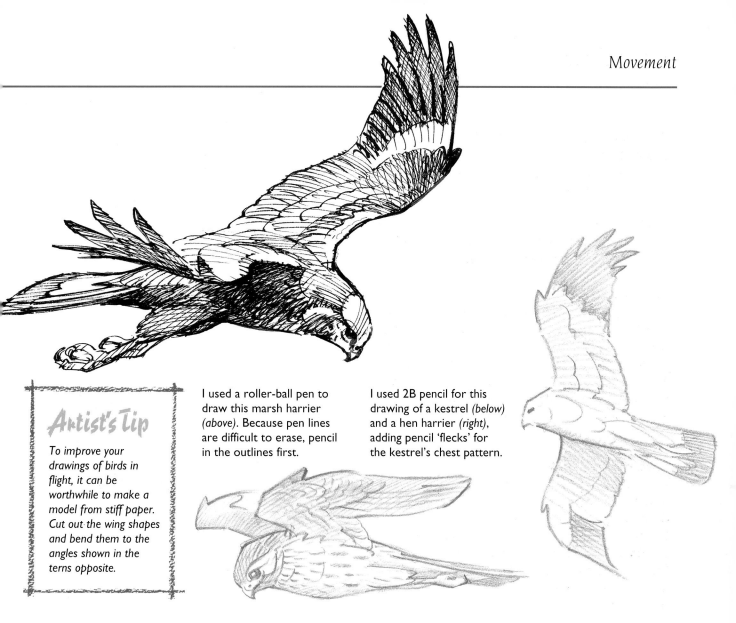

I used a roller-ball pen to draw this marsh harrier *(above)*. Because pen lines are difficult to erase, pencil in the outlines first.

I used 2B pencil for this drawing of a kestrel *(below)* and a hen harrier *(right)*, adding pencil 'flecks' for the kestrel's chest pattern.

## The marsh harrier in flight

Soaring on thermals, hovering on the wind, or dropping dramatically on their quarry, birds of prey are the great masters of the air currents.

On this page, I have done a pen drawing of a marsh harrier, poised on the breeze. The bird works slowly upwind. It uses its sharp ears and eyes to scan the reed beds and hunt down its prey. (Peering, head-down, is a characteristic of many hawks. Other birds, such as pigeons and waders, fly with their heads up.)

The drawing shows the near wing end-on so that it is extremely foreshortened: the long 'fingers' of the primary feathers, the zig-zag of the bent wing with its elbow and 'wrist' become condensed in shape.

## The hen harrier in flight

When fully stretched, the wings of the hen harrier are the same shape as those of the marsh harrier. Notice how they turn forward from the 'elbow', where they join the body, back at the 'wrist', and back again to the primaries.

## The kestrel in flight

The kestrel's habit is to hover. In a high wind, it has to streamline itself to remain in the same place. Its wings are bent forward, up, and back, with the *alula* or 'little wing' on the outer edge slotted out to reduce turbulence. The body itself has an aerofoil-like surge to its shape.

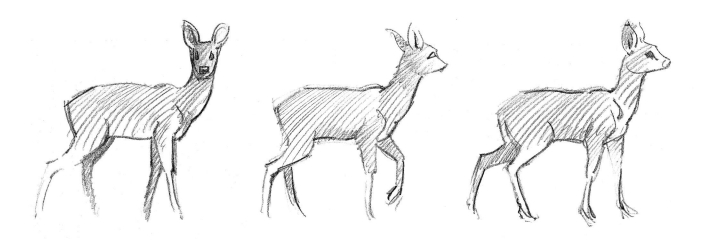

### The deer in motion

Long-legged animals such as the deer are obviously quite able to stand four-square with a leg on each 'corner', but this stance is rare. In fact, in its normal standing position, the deer will have the two feet on one side of its body closer together than those on the other side. You can see this in the first pose in the sequence of movements above and below: the feet on the far side are closer as the legs come together, while the feet on the viewer's side are splayed outwards.

This arrangement enables the deer to remain stable as it lifts its feet on alternate 'corners', as in the second movement of the sequence. It shifts its weight forwards, carrying the stationary limbs with it – to arrive at the third pose, in which the feet are closer together on the viewer's side.

This sequence will continue as the deer walks forward into the fourth pose, the rhythm unchanging as long as the animal is not alerted.

### Picking up speed

If the deer starts to run, as in the fifth drawing, it picks up speed by cantering. The rear legs tend to thrust together, and the two front legs still work alternately to assist its onward movement.

### Bounding along

If the deer picks up real speed, it begins to bound, as in the movements six, seven and eight. This allows it to cover greater distances, and to avoid broken branches and ground litter.

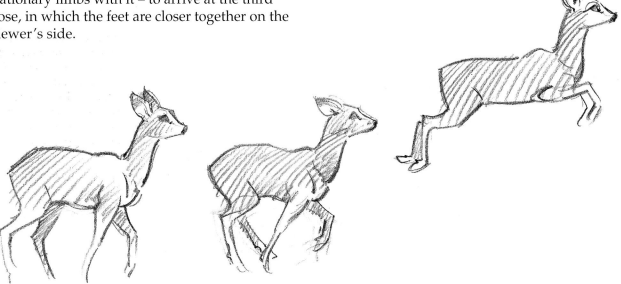

As it bounds away through the woodland, its body stretches out and the limbs lift to maximum height and width, with front and back limbs working in unison. As it comes down to land again, it 'puts on the brakes', with its body contracting like a spring to spread its weight across all four feet.

**Using photographic reference**
Capturing movement by watching a live bird or animal can be difficult – most of these creatures move too quickly for the human eye to follow. This is where photographs or, better still, videos, can be an invaluable source of reference. If you have an appropriate video, you could 'freeze-frame' a moving sequence at intervals, and sketch what you see.

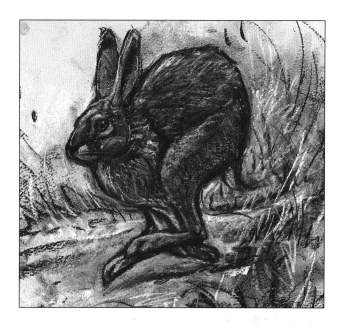

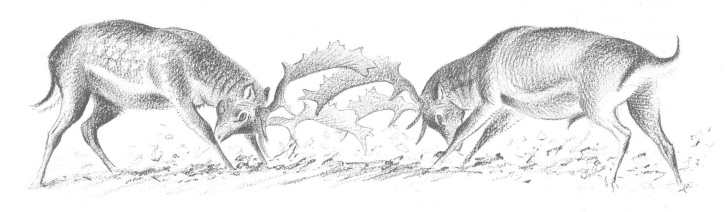

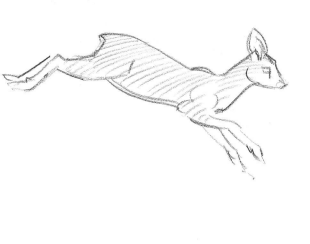

To capture subjects that might move too fast for the eye to follow – such as the jumping hare *(top)* or the stags *(above)* – freezing a single 'frame' in a wildlife video can provide the reference you need.

51

# The Complete Picture

Having learned about the various elements that contribute to the distinctive character of different birds and animals, now is the time to put this knowledge into practice by looking more closely at two individual creatures – in this case, the golden eagle and the fox.

## The golden eagle
This romantic bird is an inhabitant of crag and moor, where it lives by its hunting skills. Its huge feet are adapted to grasping its prey, such as hare and ptarmigan. It is usually to be seen only at a distance in the wild, but many bird collections will have an example, where you can get a chance to draw at close range.

## Wings and feathers
The golden eagle's flight feathers are large and all of them seem to emphasize the ruggedness and strength of this magnificent bird. The great 'fingered' wings that carry it up on thermals fold up when not in use, to give the bird a rectangular appearance.

Its plumage is carried loosely. Each of the bird's movements are enhanced by twists and flows of the feather masses as they change their patterns and directions.

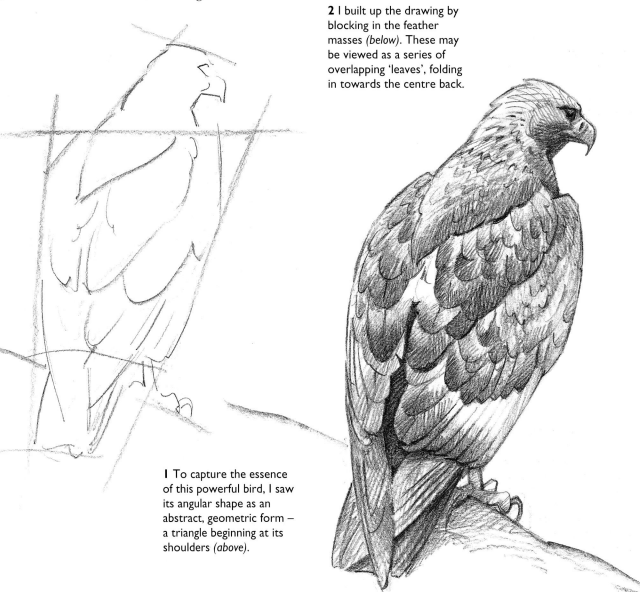

**2** I built up the drawing by blocking in the feather masses *(below)*. These may be viewed as a series of overlapping 'leaves', folding in towards the centre back.

**1** To capture the essence of this powerful bird, I saw its angular shape as an abstract, geometric form – a triangle beginning at its shoulders *(above)*.

52

### Head and beak

If the body suggests power, the head is even more impressive. The crown is flattish and the hooked beak grows out in a continuous line from the brow. The gape (the visible mouth area behind the beak) is large for swallowing chunks of meat and stretches back under the eye.

The eye is large and deep-set, and its fierce appearance is emphasized by the sternness of the brow. In profile, the eye continues the line of the beak. The cheek feathers sweep up to cover those growing down from the crown and the neck, and seem to counter-balance the downward thrust of the hooked beak.

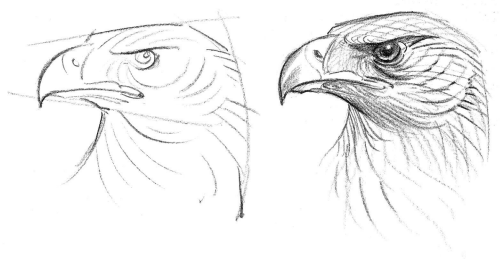

**1** To begin this head *(right)*, I emphasized the flat crown and the way in which the beak 'grows' out of it. The bottom line of the beak and the bird's chin are virtually one, stretching right back under the eye.

**2** I drew the cheek feathers radiating out from beneath the eye and down into the neck, where they change direction and move into a downward flow *(far right)*.

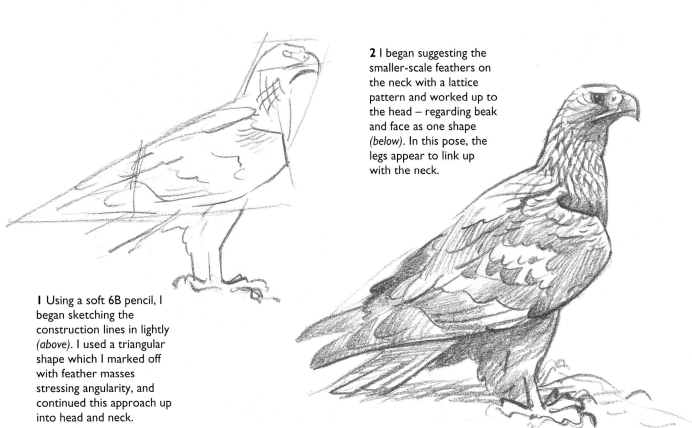

**2** I began suggesting the smaller-scale feathers on the neck with a lattice pattern and worked up to the head – regarding beak and face as one shape *(below)*. In this pose, the legs appear to link up with the neck.

**1** Using a soft 6B pencil, I began sketching the construction lines in lightly *(above)*. I used a triangular shape which I marked off with feather masses stressing angularity, and continued this approach up into head and neck.

**The fox**

The fox is a hunter, both graceful and intelligent. It lives off its wits, despite persecution. It has gradually colonized the suburbs, and this has given us greater opportunities to observe it.

The fox is a member of the dog family, but has some cat-like qualities, such as nimbleness, forward-facing eyes, a small muzzle, a long tail, and big ears.

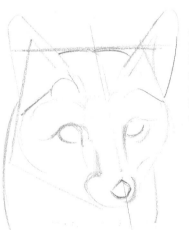

1 Drawing lightly with a soft pencil, I constructed a pentagon shape for the head. I marked out the shape of the muzzle running up to the eyes, and indicated the triangles of the ears.

**Looking at the head**

On these pages I explain how to go about drawing the fox from basics. The male has a well-developed, bushy head and nape which provide a useful bulk to work with. These can be simplified by drawing them within a pentagon, with one corner pointing down for the nose, and the large triangular ears with their rounded tips emerging from the top two corners.

The eyes and the muzzle link up to form a single pattern, and the forehead is quite high. When leaving highlights in the eyes, remember that the transparent upper half of the eyeball is in shade cast by the brow. The second drawing of the head below explains the principal fur masses as they grow up and over the head. They coincide with certain muscles, such as the ones behind and in front of the ears.

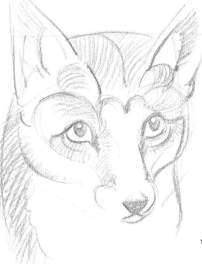

2 I worked into the head with more detail, strengthening the tone, and suggesting fur directions and masses. I began the pupils in the eyes and created highlights by leaving the paper blank.

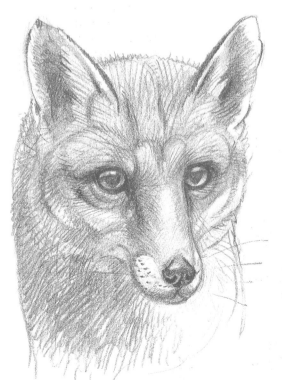

3 The finished drawing, using a full range of tones from a 9B pencil: the darkest ones are reserved for inside the ears, the eyes and the nose.

*Artist's Tip*

*The simplest way to define the rear leg shape of a fox (or any other similar animal) is to draw a 'question mark'. The front legs can be rendered with a zig-zag line, which straightens out at the end of each step.*

## The fox in movement

When drawing the animal on the move, it is important to capture its fluidity of line, heightened by the line of its long bushy tail. In the pose here, showing a fox moving at a cautious pace, I show the tail and body in virtually one rhythmic line moving to meet the neck. The neck itself curves up to the head, which, with its pointed muzzle, suggests a narrow triangle.

## Alternate movements

Most long-legged mammals walk in a similar way to the fox. The feet come together on one side and part on the other, alternatively with each pace.

**1** The walking fox – quickly sketched – emphasizing flow and movement. Notice the strong line of the body curving up from the tail and the way in which the neck curves up into the chin.

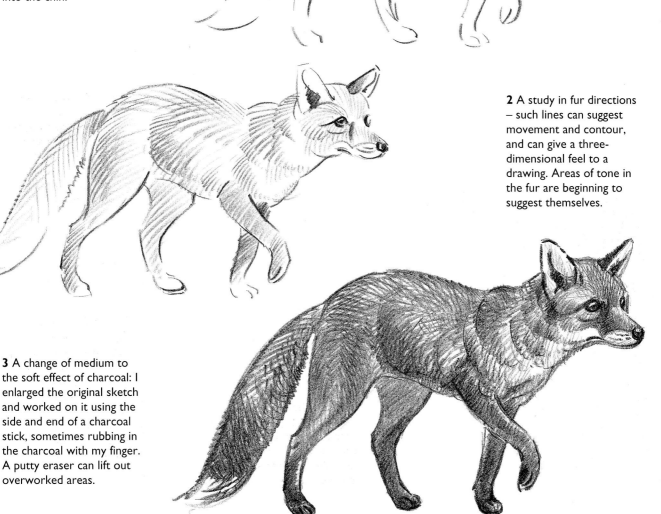

**2** A study in fur directions – such lines can suggest movement and contour, and can give a three-dimensional feel to a drawing. Areas of tone in the fur are beginning to suggest themselves.

**3** A change of medium to the soft effect of charcoal: I enlarged the original sketch and worked on it using the side and end of a charcoal stick, sometimes rubbing in the charcoal with my finger. A putty eraser can lift out overworked areas.

# Sketching

Try to get into the habit of sketching as often as you can. Filling up your sketchbook in this way will not only improve your drawing skills, but will also provide an invaluable source of reference for later use. You can sketch almost anywhere – on holiday, on a day out, in the park, or simply in your own back garden.

**The basic kit**
Keep your sketching kit as light as possible. I have a camera-type shoulder bag. In it I carry a tube containing a couple of brushes (one a medium-sized, pointed brush, the other a square-tip), two pencils, an eraser, and a pencil sharpener. A few tissues for sponging up paint can go in the pocket. My bag also holds a small, cheap paintbox, a plastic water bottle and cup, and last, but most importantly, my A5 (15 cm x 22 cm) hardback sketchbook.

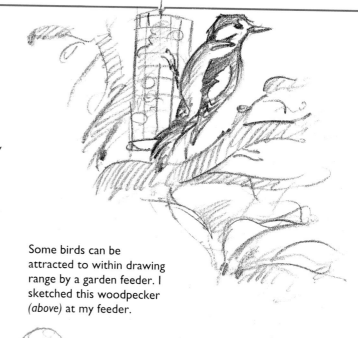

Some birds can be attracted to within drawing range by a garden feeder. I sketched this woodpecker *(above)* at my feeder.

Quietly feeding hedgehogs make good subjects *(below)*. Tempt them with meat and water, not bread and milk.

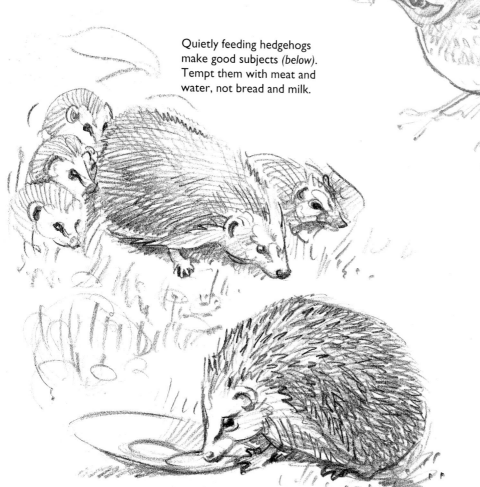

Sketchbooks are useful for noting characteristic behaviour, such as that of this song thrush *(above)*, smashing a snail shell.

*Artist's Tip*

You can sketch garden birds from your kitchen window if you set up a feeder. They move quickly, but your many sketches, even if only squiggles, will add to your knowledge.

### Extra equipment
If you want to make larger studies of reeds and
water, say, for a drawing of ducks, take out a
small, light (3-ply) drawing board with your
cartridge or watercolour paper taped to it.

Make sure that you carry waterproof clothing; a
blow-up cushion is also useful for sitting on the
ground. You will need binoculars, of course, and
a telescope, if you have one, so that you can
keep your subject in the frame while drawing.

### Observation posts
Cars make good observation posts – but make
sure that you check your mirror before you slow
down to watch that deer you've spotted! Nature
reserves offer wonderful opportunities to work
from hides, at your ease, unobserved by the
birds and animals.

Look out for unusual
effects to record in your
sketchbook. The silhouette
of this heron *(above)* was
reflected in the mirror-like
surface of the water below.

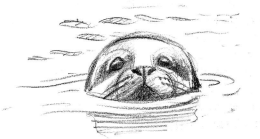

Seals are obliging subjects
*(above)*. These inquiring
creatures will follow you,
swimming offshore, as you
walk along the beach.

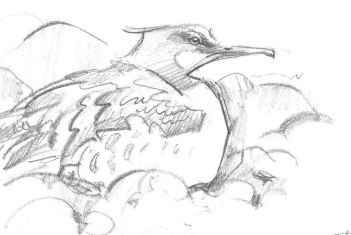

I watched this female
goosander *(above)* through
binoculars, as she rested on
rocks by a stream.

Seals are gregarious – the
young stay close to their
mother. When they are not
fishing, they bask on
exposed rocks, providing
an opportunity for some
discreet sketching *(right)*.

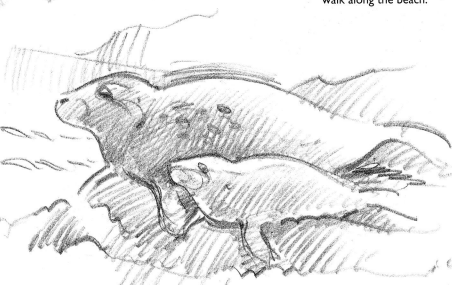

# Framing and Composition

'Framing' refers to the way in which you select an area of what you see for your drawing, or give a subject more or less space by altering the picture's borders. 'Composition' is simply the means by which you can organize the images within the picture area to give maximum visual effect to the idea or mood you wish to express.

### Trying out different compositions

When planning your composition, never accept the first arrangement that comes to mind: do various little thumbnail sketches to try out different placings before making a final choice.

### Placing your subject

You are free, of course, to place your main subject anywhere you like within the picture's frame. The one place it's best to avoid, however, is bang in the middle – a position both static and boring to the eye, which always seeks a sense of movement. The trick is to place your subject somewhere off-centre, as I have done with the single swan and cygnets. Some artists favour placing the subject on the classic 'third' – that is, a third of the way into the picture. This treatment gives space for potential movement, so important in wildlife pictures.

### Getting a balance

When you begin working up the background to your subject, it's important to get a balance between the two. Never make these background details too distracting or dominant – they should be just strong enough to suggest space and depth, without competing with your subject. In the drawings on this page, I have introduced rushes, meadowsweet and alders to provide a natural frame for the birds.

In my first trial sketch *(below left)*, I filled the frame with the whole swan family. This composition produces a feeling of activity and movement. In the second sketch *(below)*, a single swan and cygnets are framed to give them more space, creating a mood of quietness and peace.

> ## Artist's Tip
>
> Cut out two large L-shaped pieces of card or thick paper, and lay them around your drawing to make a frame. You can then move this frame around, widening or reducing the picture area inside, to find the best place for the borders.

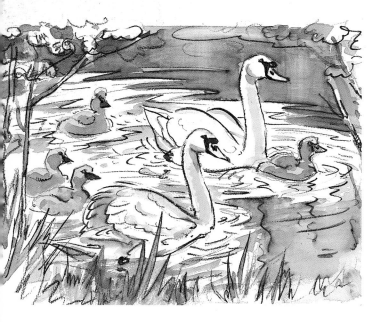

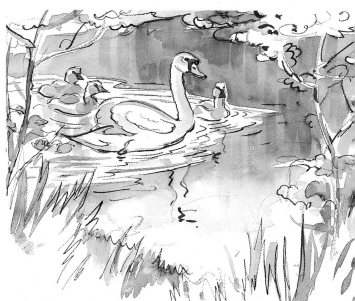

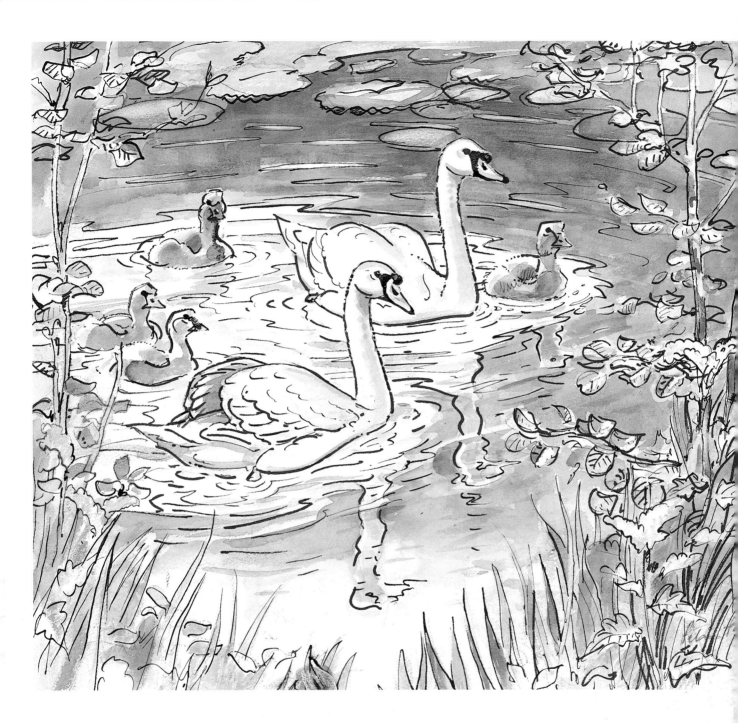

By playing around with my trial sketches and adjusting the framing, I arrived at a compromise between the two sketches *(above)*. The group itself had to remain a coherent whole, yet at the same time had to be visually interesting.

The arrangement is essentially a V-shape. The swan in the foreground turns away from us, while the second turns in to block this movement. Two of the young birds are headed towards us, which helps to involve the viewer.

# In Setting

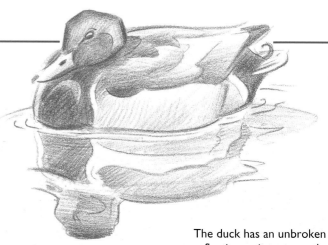

It is fascinating to draw and study a bird or animal in isolation, yet somehow a picture means more if it shows something of the creature's habitat. This need be no more than a suggestion, such as a few pencil or pen strokes indicating reeds or pebbles, or even a shadow cast on the ground. In the drawings below, for instance, I show how a few carefully drawn leaves can frame a finch.

### Thinking about scale
A sense of scale in your picture is very important. At close range, a small bird like the greenfinch will be surrounded by relatively large leaves – the scale of the leaves indicates the bird's size. If, on the other hand, you are showing a distant fox in a large field, details like leaves should shrink and merge into the larger shapes of tree and hedgerow. Textures like pebbles or cornstalks can be rendered with small marks made by pencil, pen or brush. Loose charcoal marks or smudged effects on textured paper can convey distance and atmosphere.

### Planning the setting
A simple setting like the lilac leaves I have used for the greenfinch need careful thought as you plan your drawing. I drew the leaves first,

A floating water bird like this mallard will always show some sort of reflection, which in a drawing at once places the bird in space and indicates its natural setting.

The duck has an unbroken reflection as it rests on the calm water. It needs only a few fine lines where its feathers and water meet and a slight distortion of the reflected image to convey water surface. Even in the reflection, the tones of its plumage are visible.

copying some in my garden, and taking note of their shape lengthways and end-on as they splayed out. Foreshortening made their heart-shapes even more interesting. I placed the bird centrally, but by giving the pose a twist to change its direction I have suggested space outside the drawing. This twist is emphasized by the unexpected angle at which the bird grasps the twig.

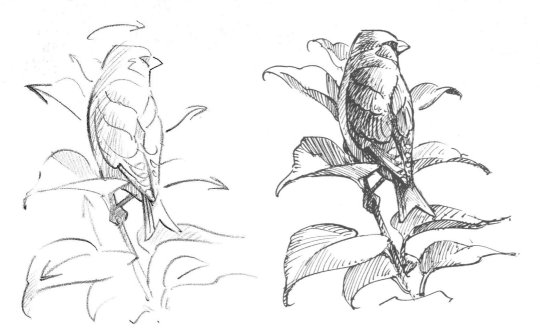

My initial pencil sketch of this greenfinch *(far left)* shows the outward and upward flow of the lilac leaves. The direction of the bird's gaze suggests space outside the drawn area.

I used a fine-pointed, felt-tip pen in my finished drawing *(left)* to sketch the delicate leaves, with their flowing lines. I carried this line through into the bird, using cross-hatching to describe its rotundity and to fill areas of shadow.

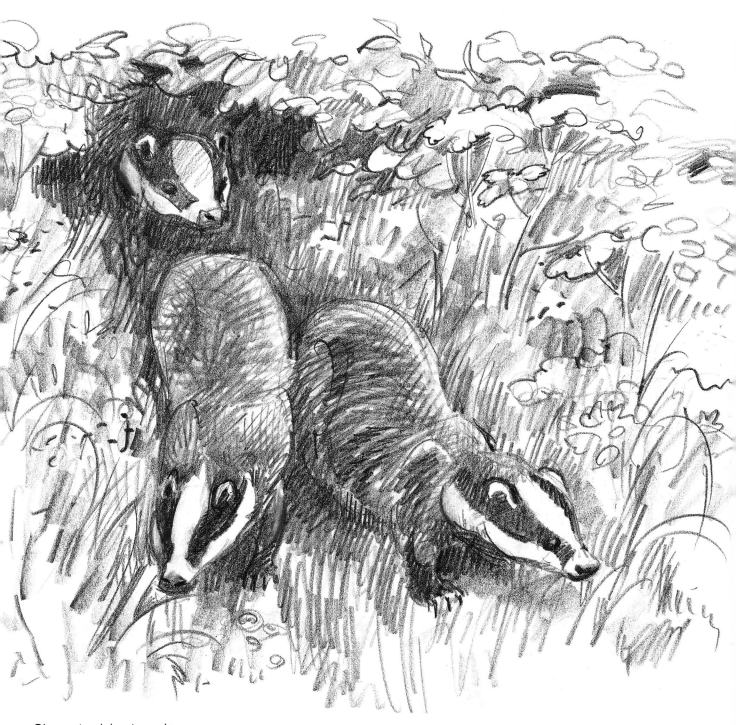

Observational drawing and field sketches, combined with a growing knowledge of animal behaviour, will add authenticity to your pictures, whether you are depicting a badger in its woodland, or a pheasant in its brambles.

# Working from Photos

Artists have always made use of photographs, and film and video can provide the wildlife artist with more information than ever before.

I always carry a still camera with me on my trips, but use it mostly for recording background detail: I never rely on the camera entirely and always sketch as well. Photographs offer us only one small moment in time; sketching can capture movement, space and continuity, as our eyes scan the whole scene.

If you want to sketch in comfort, modern wildlife films, recorded on video, provide the ideal opportunity. Although both camera and animal move, the freeze-frame facility will allow you to stop the film at any point to draw the animal carefully.

## A starting point

We do not have to be slaves to the photo: it can be a departure point for a range of approaches. Here, I show a photo of a grey seal pup, taken on a remote island where the species breeds, and show two different ways of using it.

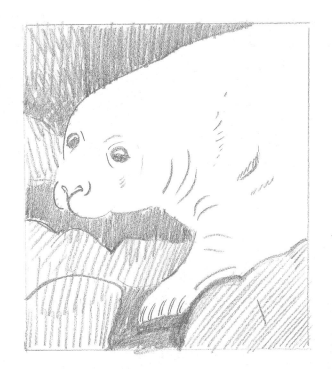

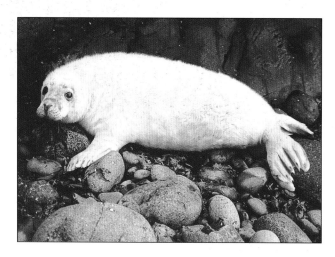

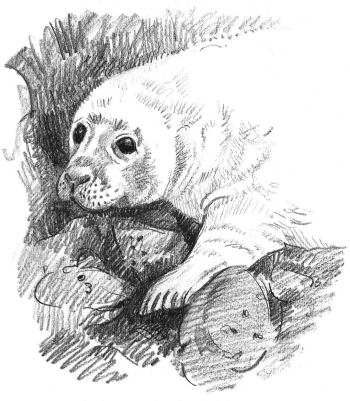

I began the pencil portrait *(top right)* by looking closely at the seal's features – its large eyes, its nostrils and its muzzle, and the way in which they relate to each other to create character.

I used a soft 9B pencil to explore the tonal contrasts, adding to them carefully *(right)*. I kept the negative shapes of the dark rocks in mind; these helped to create the seal's shape.

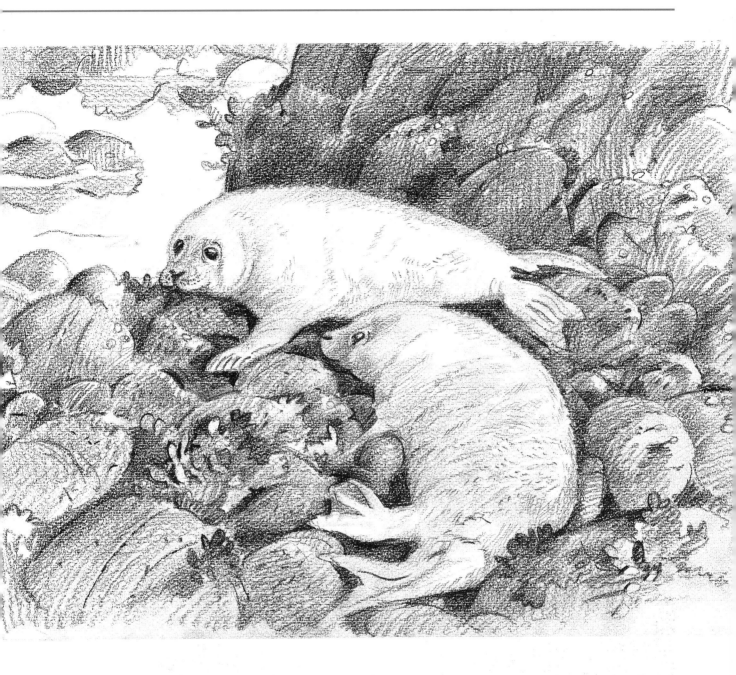

### Varying the composition

The drawing above has extended the simple portrait opposite into a more complex composition. The two seals are, in fact, the same animal, shown from different angles. I used the curved rhythmic shape of the seal in front to lead the eye to the focal point of the second seal's face. The rock behind was, I felt, too solid, so I used 'artistic licence' to break it up with a gap suggesting a tidal pool.

For this drawing, I chose a soft, waxed carbon pencil on a textured watercolour paper. This combination enabled me to build up the texture of the seals' coats without losing their pale tone, and to work heavily into the wave-rounded boulders into which the seals fit so snugly.

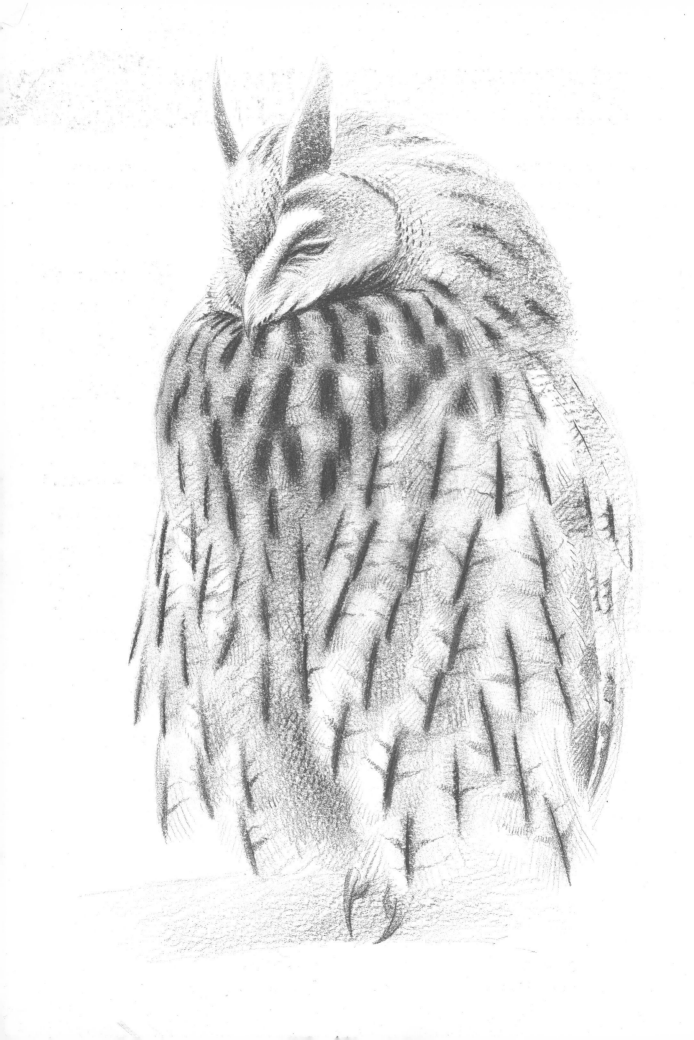